42

D0579564

12

A Direct Approach to Painting

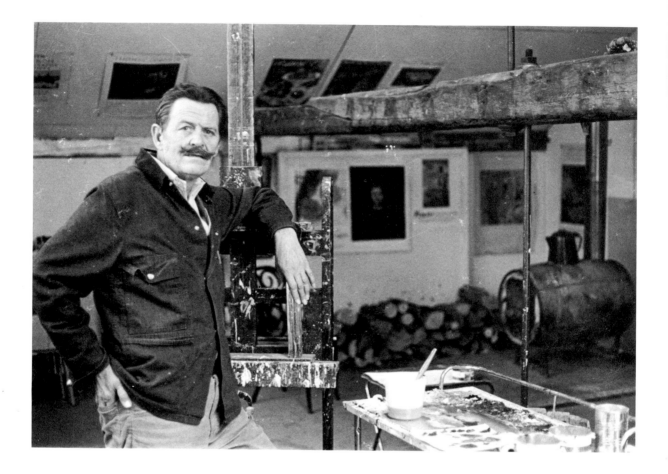

A Direct Approach to Painting

Expand Your Horizons as a Painter

Alfred C. Chadbourn, N.A.

NORTH LIGHT PUBLISHERS
WESTPORT, CONNECTICUT 06880

This book is dedicated to all my students.

Published by NORTH LIGHT PUBLISHERS, a division
of FLETCHER ART SERVICES, INC., 37 Franklin
Street, Westport, Conn. 06880.

Distributed to the trade by Van Nostrand Reinhold
Company, a division of Litton Educational Publishing,
Inc., 135 West 50th Street, New York, N.Y. 10020.

Manufactured in U.S.A.
First Printing 1980

Library of Congress Cataloging in Publication Data
Chadbourn, Alfred.
 A direct approach to painting.

 1. Painting—Technique. I. Title.
ND1500.C45 751.45 80-17042
ISBN 0-89134-028-9

Edited by Fritz Henning
Designed by David Robbins
Composition by Stet/Shields, Inc.
Printed and bound by The Rose Printing Co.

"A picture, before being a war-horse, a nude woman or some anecdote, is essentially a two-dimensional surface covered with colors arranged in a certain order."

Statement by Maurice Denis (1870-1943) a member of the School of Pont Aven called the "Nabis" or Symbolists.

CONTENTS

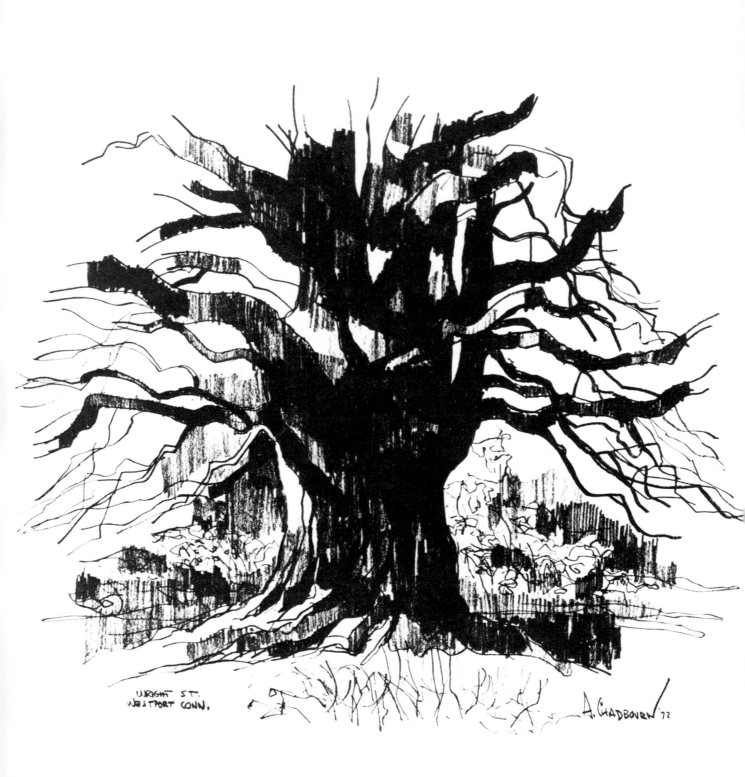

WRIGHT ST.
WESTPORT CONN.

A. CHADBOURN '72

6

INTRODUCTION

YEARS AGO I was discussing the seemingly difficult task of teaching watercolor painting with Dong Kingman, the renowned watercolorist. He thought for a moment then said to me, "You know, Chip, I think I'll write a book on 'How To Paint Watercolor The Easy Way'—then I'll print it in Chinese."

This book is not about watercolors, nor is it in Chinese, but Dong's dilemma had a point. There is not one painter I know who does not have the same problem: how to teach painting and keep it simple.

Most of the thoughts expressed in this book, as well as some of the techniques involved, are similar to problems I share with my students. These classes are unstructured, follow no dogma or logical plan of reasoning. Such structure is not possible because of the varied experience of my students. If I were teaching a formal class in an art school, assigning grades at the end of each semester, and all the students were more or less the same age, then our studies would be less freewheeling and diversified.

As an art teacher, the two most frequent comments I hear are, "But Mr. Chadbourn, you make it look so easy," and the corollary lament, "If I could only loosen up." The answer to both questions is simple: time and practice.

The title of this book may imply a looser, freer way of applying paint. I don't want to suggest I'm against "tight," highly modeled, realistic painting, nor do I expect you to start throwing paint around with abandon or take up drip painting a la Jackson Pollock. I hope, however, after some of my demonstrations and your own experimenting, you will feel sufficiently comfortable with the medium and your own abilities to be confident you can achieve your goals. These are the ingredients you need to derive a sense of gratification from your painting efforts.

I am a big believer in use of art reproductions and art books to teach art. My studio is festooned with them and I use them constantly for my own enjoyment and for teaching. What better way to become familiar with art? Sir Kenneth Clark said, "A strong response to works of art is like having a comfortable account in a Swiss bank. One can never become emotionally bankrupt."

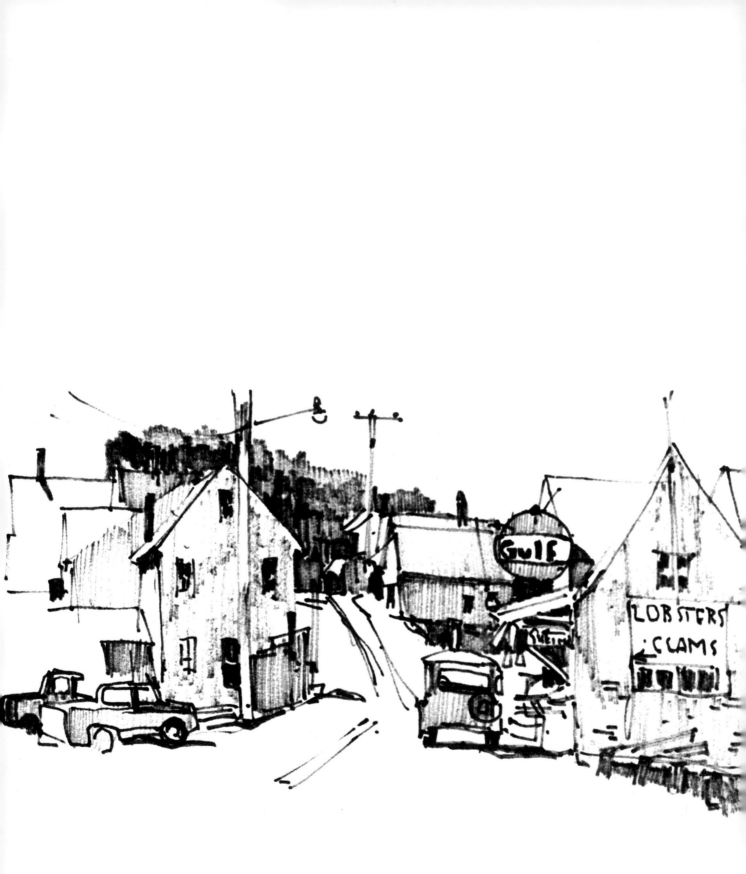

I have collected posters and reproductions for years. I started as a student at Beaux-Arts in Paris. Prints were cheap and plentiful and they have been a part of my "luggage" ever since. I don't frame my reproductions or consider them for anything more than what they are—reference, inspiration, and information. As such they are indispensable, particularly if you don't have a good museum nearby. At times I use prints when I run into a problem while painting. Let's say a still life with the sun streaming through a window on the objects in front of me is causing trouble. While taking a break it's a great aid to be able to refer to a Pierre Bonnard book and see how he handled sunlight, or to pick up an Edward Hopper postcard of an interior and see what he did with splashing light. My purpose is not to imitate their brush-work, copy their style or use of color, but rather to find a clue to their thinking.

The problems students have with their painting are not that dissimilar from the ones I have. The only real difference is I may have been at it longer and deal with these problems on a daily basis.

The abstract painter, Joan Mitchell, once said she likes to carry the painting around in her head for a week or so. I hope you will acquire the same habit so that when you're not actually at the easel you are thinking about your painting during odd moments of the day. Get involved with your work, let it become a larger, more meaningful part of your life.

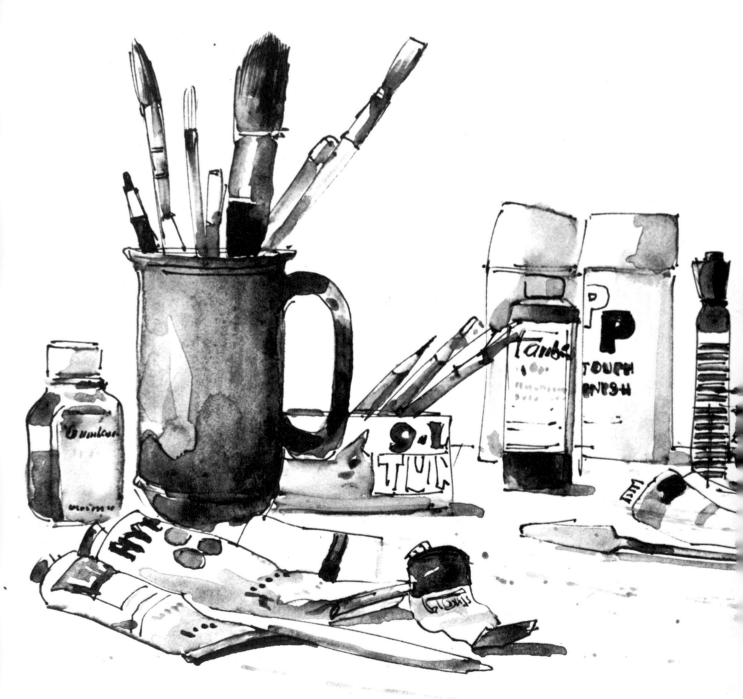

CHAPTER ONE
MATERIALS

BRUSHES

THE VARIOUS TYPES of brushes shown on page 12 should pretty well handle all your needs. Brushes are the tools of the trade; and, if you want to produce the best work you are capable of, I suggest you buy good ones. You should be familiar with all types of brushes, but for our purposes let's stick to the ones in the drawing.

Flat bristle brushes will give you a fluid, limber stroke when used with a lot of turpentine, useful at the beginning stages of a painting. When buying a brush be sure the bristles curve in at the corners. Otherwise they will splay out and give you trouble when you paint.

Bright bristle brushes—my favorite—have a shorter body of bristles allowing for more vigorous strokes, and are efficient in transferring large globs of paint to the surface. They are very useful for scrubbing in and can take a pretty good beating.

The *flat sable* brush: Although the large sable brushes are called the aristocrats by some artists, I feel their prohibitive cost outweighs their usefulness. Flat sable brushes produce a good soft edge generally desired by portrait artists. They are also fine for varnishing the finished picture or for glazing. In general I avoid them.

Round bristle brushes for some odd reason are used by Europeans much more than in this country. They are good for soft, fuzzy edges or for a daubed or pointillist technique. Bonnard used them almost exclusively although he wasn't a pointillist. I rarely use them as I like a choppier stroke, but you might try them.

FLAT BRISTLE BRIGHT BRISTLE FLAT SABLE ROUND BRISTLE

POINTED SABLE

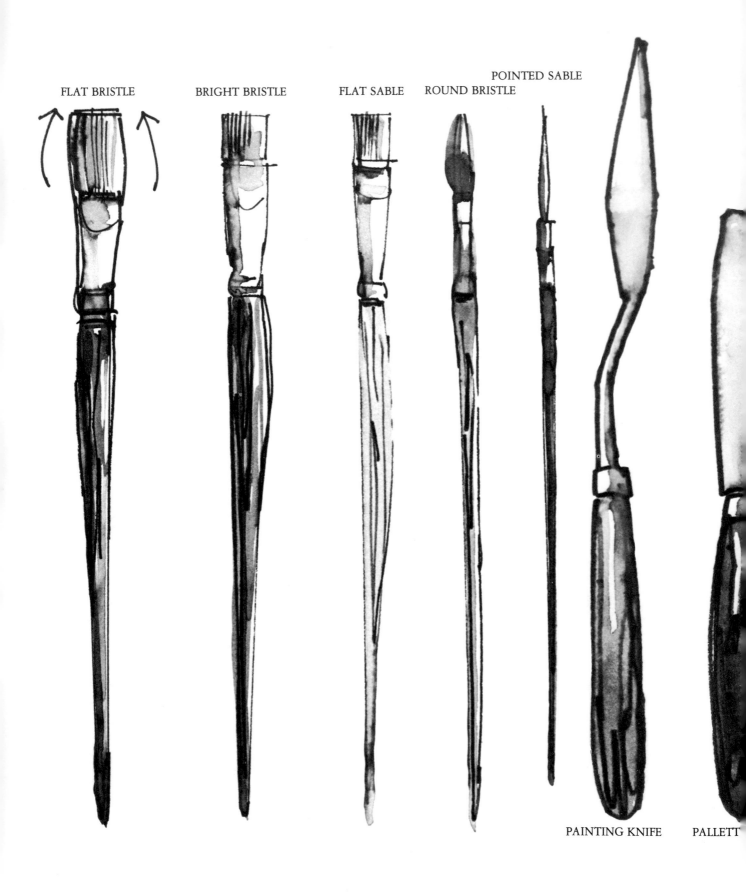

PAINTING KNIFE PALLETT

Pointed sable or line brushes vary in number by the manufacturer and are sometimes called scriptliner or striper. They are good for fine details like thin branches or telephone lines, but are generally too fine for initial drawing. Buy the cheapest ones you can get as they wear out quickly.

These are the sizes and types of brushes I recommend: Flat bristle #10, 7, 5, 3; Bright bristle #10, 7, 5, 3, and one cheap line brush.

ANVAS AND SIZES

There are two kinds of canvas: linen and cotton. They both come in a wide variety of weaves and weights. Obviously the linen is more expensive; the imported French and Belgian linens outrageously so. Unfortunately, once you get used to these fine surfaces it is hard to be satisfied with anything else. You will have to experiment on your own as to which weight or weave suits you best. As a general rule, most rough weaves are used for landscapes and still lifes, whereas the finer weaves are more suitable for portrait and figure work.

There is nothing wrong with a cotton canvas so long as it is not too porous. Hold it up to the light and if you see too many little holes, it is going to be hard to cover. A good duck or sail cloth type cotton is an excellent, durable canvas. Where I live in Maine I stumbled across some canvas used locally for lining shoes. I tried it and found it to be a good, tough serviceable canvas. It was dirt cheap. Sometimes you can find good pieces of cotton worth investigating in remnant or fabric outlets.

By sizing and stretching your own canvas you will save at least 30 percent of what a ready-made canvas will cost you in an art store, and you will probably end up with a superior product. Stretching a canvas is a big bore for most people, but well worth the effort. On page 15 is a step-by-step demonstration on how to prepare and stretch a canvas. Once you have done a few, you will find it is quite simple and worth the trouble. Generally I stretch my canvases during the bad weather when it is not particularly good lighting for painting. Having fresh, stretched canvases around in the studio is like having money in the bank.

Masonite is a popular painting surface which has many pros and cons. On the positive side, it is cheap and most lumber yards will cut an eight by four foot sheet into sizes you want. Try to get the untempered masonite as it is less apt to have foreign materials in it. Use the smooth side for priming. Give it a light sanding and at least two coats of gesso. It is very durable and you cannot poke a hole in it or dent it, which sometimes happens to stretched canvas.

Many artists find the masonite surface too smooth and glass-like to work on. When using it you may have to modify your painting habits as the paint will have a slippery quality when applied with any medium. Some artists like this and use it effectively. One way to get around this slippery effect is to glue a piece of canvas to the masonite. Such a procedure eliminates cost advantage, but you have a firm backing to work on. Polymer glues such as Hyplar or Elmer's, diluted with a little water, work well for mounting the canvas. (A divorcee in my class used a drawer full of her ex-

Here are three types of canvas commonly used for painting:

A. This is the common unprimed cotton canvas. Many art stores sell the canvas presized, but generally the manufacturer does not identify what sizing was used. When you prepare your own canvas you are sure what you are working on. The ideal weight for cotton canvas is #10. (The weight in ounces per yard of duck.) It is an inexpensive canvas and doesn't absorb much moisture, although uniformity of quality can be undependable. When you buy canvas be sure the surface is smooth and does not have loose threads or stitches.

B. Smooth linen canvas is a popular product. The imported Belgian or French linens are considered the most permanent and long lasting textile. They are also most expensive.

C. This is a rough textured linen and heavier weight. It is hard to stretch because of the toughness of the fibers. Many artists like the rough texture to work on.

husband's linen handkerchiefs for this purpose which made a very fine grained surface on her panels. I assume the ex-husband has been relegated to tissues.) Another disadvantage to masonite is that in large sizes it is likely to buckle and will require some extra support on the back to keep it flat. All this makes for a heavy picture.

Canvas panels are available in a variety of sizes in art stores throughout the world. I seldom use them because I find them an unsympathetic surface to work on.

A final warning about painting over old canvases: never cover an old oil painting with polymer gesso or it will flake off. Polymer is water-based and should only be used on fresh canvas or masonite or over acrylic surfaces. If you have an old oil painting you want to paint over, the best idea would be to turn it upside down and scrape away any thick pigment with a palette knife. I do this frequently, even though it presents a problem painting over the image underneath.

OW TO STRETCH CANVAS

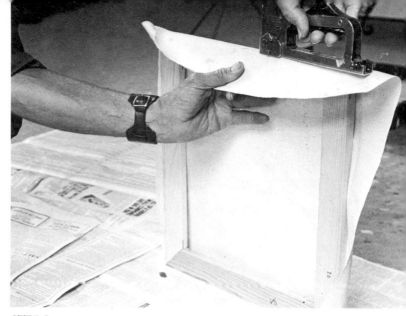

STEP I Join the mortised corners of the stretcher bars together at approximate right angles. Then, with a carpenter's square, check all corners to make sure they are square—a lopsided picture is difficult to frame. Now cut a sheet of canvas leaving at least 1 ½'' of extra material around the edges. Tack or staple one side of the canvas to the stretcher bar. Start in the middle and work towards both corners of the bar. When done, rotate to the opposite side, pull canvas taut by hand or use canvas grippers and tack or staple the opposite side. Work from the middle toward the corners. Proceed in the same manner until all sides are secured and the canvas is tightly stretched.

STEP I

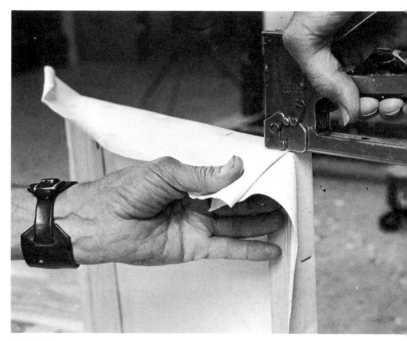

STEP II Make clean ''hospital'' folds and secure each corner of the canvas.

If, when done, you still have a few small wrinkles on the stretched canvas, take a damp sponge and wet down the back surface. When it dries, the troublesome wrinkles should be eliminated.

STEP II

STEP III

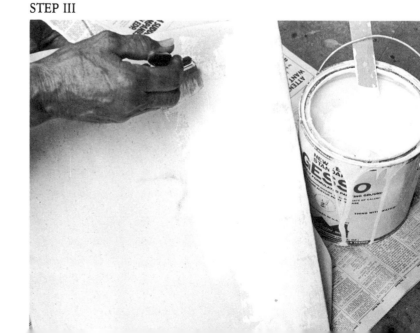

STEP III Now apply the prepared gesso in at least two or three layers. Synthetic or polymer gesso provides a flexible ground suitable for canvas. It may have to be diluted lightly with water if you want a good smooth coat. The real pros sand each coat lightly with fine sandpaper before applying the next coat, although I'm always in too much hurry to go through this stage. Since I use three coats of gesso, I always sand the final canvas to make sure no bumps show through. For added protection, be sure to give one coat of gesso to the sides or edges of your canvas. A restorer at the Boston Museum of Fine Art told me that many of the 18th century paintings he was restoring had rotted on the edges and had to be remounted on board or masonite because the sides had no sizing. Canvas will rot with nothing on it.

CHAPTER TWO
COLOR

PALETT

ON THE OPPOSITE page you will see the palette that I have been using over the years. It's a glass palette made out of windshield glass which is unbreakable and was cut to size at a glass shop. Some of you may prefer another type of surface, but I find that glass cleans easily, and when a good neutral tone paper is placed underneath I have a fine mixing area. The palette fits the top of a basinette which makes a good taboret and is a permanent part of my studio equipment. I discovered baby basinettes by following my wife to ''tag'' or ''barn'' sales, where good ones can usually be picked up quite cheaply. I find a basinette particularly useful as it holds all of my paints and brushes as well as various cans of turpentine and other odds and ends. For outdoor work I use a conventional wooden palette which fits into my French portable easel.

The arrangement of my palette is quite simple, with the warm colors on one side and the cooler colors on the top. Some of the piles of paint have built up over the years, mainly due to my laziness. This is not a recommended habit.

If you already have an assortment of paints, they can always be used along with the colors suggested here, but there is no need to buy a lot of exotic colors which are expensive and unnecessary. Also, a word of warning on kits or paint sets. Many include colors you don't need. With a little experience the palette shown here will enable you to reproduce any color you want to paint.

A WORD ABOUT DEMONSTRATION

Many good artists I know feel reluctant about doing painting demonstrations. There are a variety of reasons which can explain these attitudes. First, there are some painters whose method of working makes it difficult to describe, let alone demonstrate. How are we to know, for example, all the changes that took place in a small landscape painting by Albert Pinkham Ryder? It took almost ten agonizing

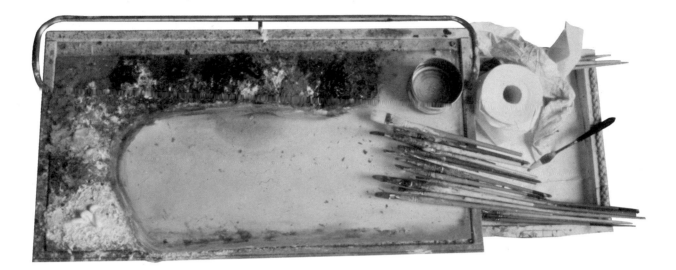

years to complete. On the other hand, when we look at some of the unfinished Cézannes we get a clear idea of how he put down his brushstrokes almost as though they were done for the purpose of showing us how he worked. It's probably fair to say that when a painter does a demonstration, he is not always going to be at his best because he is only showing part of the creative impulses that take place while he is painting. How interesting would it be, for instance, to look at a painter slumped in a chair in the corner of his studio while he is studying his painting upside down? Almost every painter I know does this from time to time to get a better idea of the total design, but for obvious reasons it would not make an exciting demonstration.

It would also be fairly safe to say most painters doing a demonstration are going to paint something they are familiar with, or something they have painted before. Logically they hope to avoid hidden pitfalls which sometimes happen when painting the unknown.

Some artists feel it is impossible to teach through demonstrations because the nature of painting is too fluctuating and illusive. Proceeding in an orderly manner from one step to another is not always the way a good painting is accomplished. Also, some excellent painters work in a tight, meticulous manner that does not lend itself visually to a meaningful demonstration. To put it another way, I doubt if Fra Angelico could show us much of the magic that went into the breathtaking San Marco alterpiece in Florence. On the other hand, it would take Manet but a few minutes to paint us a beautifully gloved hand or a few dazzling flowers in a glass vase. I don't reject one or the other, but in terms of demonstration Manet makes it easier for us to ''see'' what he is doing.

When I do a demonstration for students I make one point clear: I do not want to imply my way of painting is necessarily the best and only way to paint a picture. My purpose is only to show how I go about applying colors to the canvas in the easiest way I know. I always wish at this stage I was endowed with some of Monsieur Manet's razzle-dazzle with a brush. As we go through these step-by-step demonstrations I'll do my best to clarify any technical problems.

STILL LIFE PAINTING

I have always thought the French term "nature morte" or literally "dead nature" to be an unappealing description of one of the most enjoyable and rewarding aspects of painting. Anyone who has seen an original still life by Monet, Renoir, Van Gogh or Cézanne would be quick to agree that they are anything but dead.

Oddly enough, still life painting is a relatively new form of painting from an historical point of view and never gained much importance until sixteenth and seventeenth century Dutch Masters began to use it as a way of displaying their opulent and cherished belongings. Before and during the Renaissance, still life painting was usually relegated to a small part of the picture or as an adornment to the larger design. It wasn't until the Impressionists burst upon the scene with their exuberant quest for painting anything and everything that the still life gained its rightful place in art, culminating in the vibrating apples of Cézanne which rocked Paris off its feet at the turn of the century.

When I went to art school things were a bit more rigid than they are today, and if you wanted to take figure painting you had to have two years of figure drawing and one year of still life before you could paint the figure. This sort of basic training was felt necessary before exploring the more complex realms of the figure. I'm inclined to agree. No matter what kind of a painter you want to become, there is no better discipline than still life painting. It's also the most convenient. For the pure study of light and form there is no better substitute.

I first arrived in Paris in 1947, the year Pierre Bonnard died. There was an enormous retrospective show of his work including over three hundred of his paintings. What a joy to walk through those rooms of sheer sunlight. The impression has lingered with me ever since. Besides marveling at Bonnard's personal use of color, the thing that impressed me the most was how simple subject matter can be and still produce a powerful statement. A casual bowl of fruit or an ordinary vase of flowers becomes a brilliant and lyrical experience, like poetry in paint.

Another advantage of Paris at the time was that the giants of Modern Art were still producing with a vengeance. Exhibitions of Braque, Picasso, Matisse, Leger and Chagall were popping up all over. With the French propinquity for posters it was almost impossible not to be aware of the current trends and movements in painting.

Then too, there was always the Louvre with its great masterpieces and the Tuilleries, the Jeu de Paum, which houses a fine collection of Impressionists paintings. On rainy days you could rent an easel for a few francs and copy the masters in relative solitude, a practice I still follow when my painting seems to be in a rut.

On my return to New York in the fifties abstract Expressionism was in its heyday, and still life painting, as we generally think of it, had pretty much disappeared. Now all of this has changed, and in the new so-called "post modern" period the practice of painting recognizable objects is no longer obscured in artful disguise. Although "modernism" is by no means dead, representational work is being shown with more and more frequency. It is fortunate that we can now enjoy those "abstract" apples of Cézanne as he painted them and not reduce them to something less than they are.

When I set up a still life for myself or my students, I try to keep it simple. The photograph shows a still life I arranged for my class using objects found in my kitchen. I wanted a casual set-up to be seen as though one might come across these objects passing through the kitchen. The red drapery was added for a splash of color on the white table to help enrich the entire picture.

It is best to do several preliminary, rough sketches in order to get the "feel" of the set-up and how it is going to fit into the picture area. Shown on page 20 are three of the subjects from different angles and eye levels. The first sketch was done while sitting in a chair. Although this has an interesting impact, it lacks depth because you cannot see around the objects.

In the next sketch I was looking down on the table. Now I can see around all of the objects, but the perspective seems a bit too steep.

The final sketch is the one I prefer. I can see all the objects clearly and all the elements seem to fit into the composition nicely. Even though it is a rough sketch, I establish my overall value pattern which will guide me in my painting. I strongly urge you to get in the habit of doing preliminary, rough sketches no matter how feeble you may feel your drawing is going to look. It is a "thinking sketch," not a finished drawing. At this stage important decisions are made as to what goes where, and how the lights and darks fit into the overall composition.

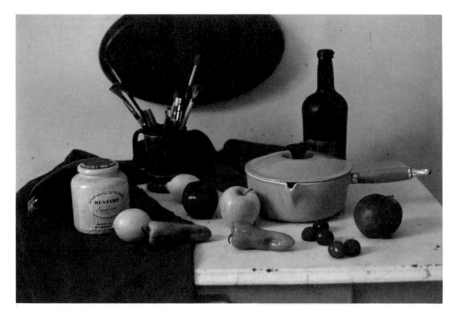

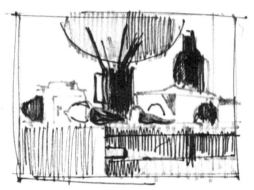

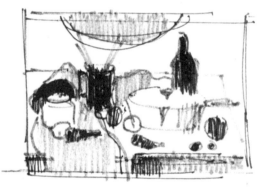

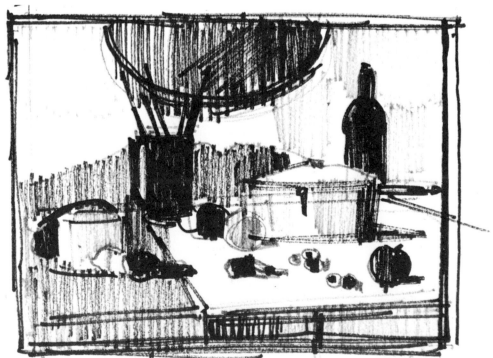

20

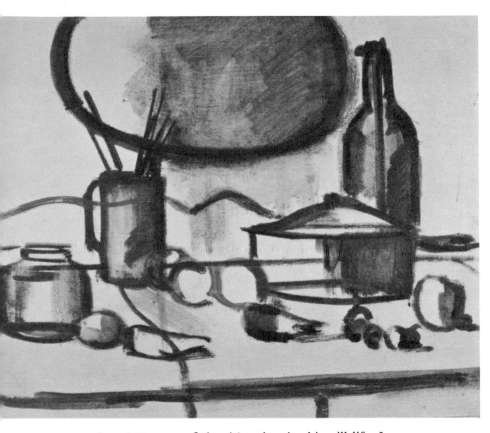

STEP I Because of the rich colors in this still life, I decided to start with the white canvas instead of toning it first. There is something that never fails to excite me about a well stretched, pristine, white canvas. It's such an inviting surface to work on.

Using lots of turpentine and raw umber, I start laying in the major forms of the still life. I use a worn out #3 flat bristle brush, although most people prefer a line brush. In any case, all I am doing now is concentrating on the placement of the various objects before me. Note how I draw through the objects like the table plane and the yellow pot. This helps the construction and form of the objects as I draw them.

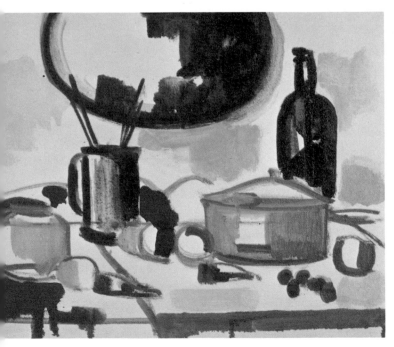

STEP II Now I start putting in the color using short, choppy strokes. This just happens to be a habit of mine, so use a more flowing stroke if it suits you best. I'm looking for the local color of objects while trying to establish an overall color relationship. I don't follow any rules about starting with the darks or lights first. My aim is to put down swatches of thin paint in order to establish some exciting color relationships. I clean my brushes with nearly every application because I want the color to be clean and fresh.

21

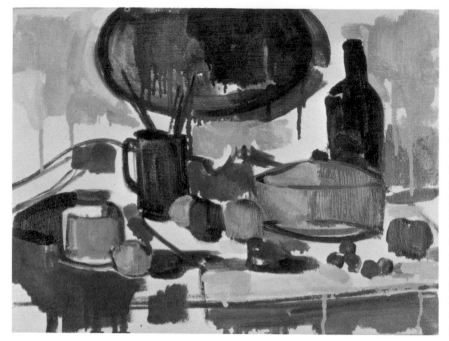

STEP III The brushes are flat bristle #10 and #5. limiting myself this way I can get the canvas cover quickly. When using thin paint, as I am here, sor of it will drip, but it can always be wiped out with rag or cleaned up later. Now closer color relationshi are indicated such as the shadow side of the yello pot, and the light and dark areas on the oval fryi pan. The local color of the fruit is kept rather f which helps to accentuate the "spotty" look of t entire picture. Although a few areas of cool color a painted in the shadows, I am not paying too much a tention to form. An overall, exciting color relatio ship is what I'm striving for. While painting, I ke moving back and forth from my easel to get a bett view of the picture. Squinting at the subject keeps r from getting too involved in unnecessary detail.

STEP IV Up to this point I have been using reasonably thin paint. Now comes the fun part. I begin to load up my clean brushes with plenty of pigment. I switch from turpentine and use my medium which will give the paint a more buttery effect. I keep squinting at the still life and look for the richest color areas that will be enhanced with the thicker pigment: the red cloth, the yellow pot, the table top, etc. Remember that thick paint is generally used in the light struck areas. The edges on the frying pan are

cleaned up, as well as a few other places where I w carried away. A few highlights are added on t mustard jar, yellow pot, brushes in the pewter ju etc. When a painting gets to the final stages, t amount of finish you add is a personal thing. Ge erally, I like to keep the painting somewhat loos That is why I do not get into all the little details th may detract from the visual impact that first got n excited. Details should enhance an object but nev interfere with the overall pictorial design.

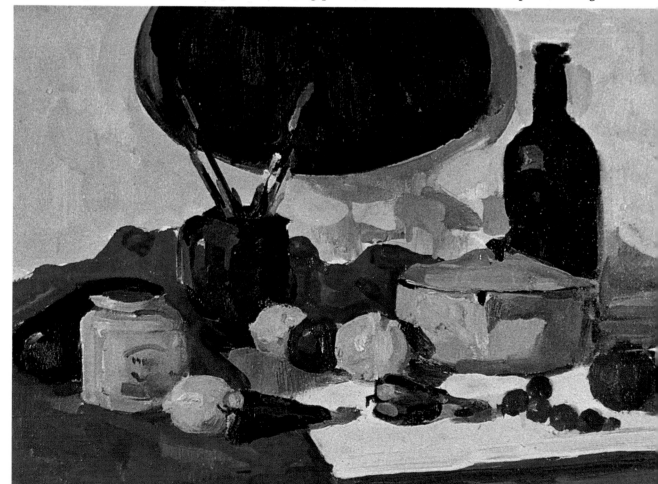

LANDSCAPE DEMONSTRATION

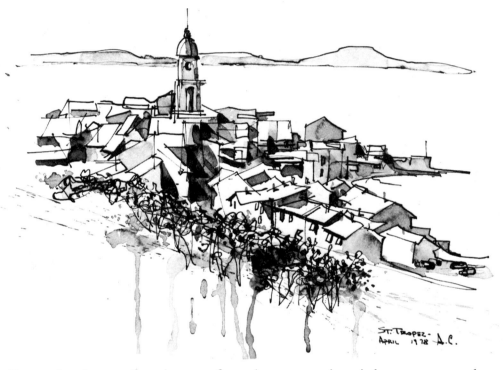

St. Tropez has been a favorite spot for painters ever since it became a popular resort in the 1920's. I spent a couple of years of my childhood there which must have something to do with my fondness for the place. Returning there on my fiftieth birthday a few years ago, I had the same disillusions many have about childhood memories of places of our youth. The buildings still look the same, but the people, swarms of them, have made the place a beehive during the summer months. However, in October things improved. The colorful pink and ochre buildings along the quays with overcrowded restaurants, the bright striped awnings and the deep blue harbor jammed with luxury yachts still make it an inviting place to paint.

The pen-and-ink sketch was done from a hill that overlooks the town, offering a panoramic view of the bright, tiled rooftops and sun-splashed buildings dominated by the large church tower. I used a line drawing with a few diluted washes to capture the almost cubistic effect of the roofs and general geometric feeling of the buildings against the strong horizon.

Sketches have an uncanny way of bringing things back into focus as though time had stopped; and the vision is just as clear and fresh as the day the drawing was made. Even though I made this sketch over a year ago, I find it quite satisfactory to use as a basis for the following painting demonstration.

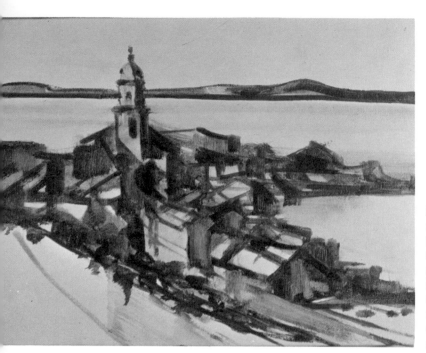

STEP I With the sketch as a guide, I start laying in the major picture elements with thin washes of turpentine and cerulean blue. The horizon and general structure of the buildings is held fairly close to the sketch. I like using different colors at the "drawing in" stage, and blue is particularly useful for seascapes or snow as it helps to unite the values. Also, the rooftops are red and orange, and I wanted a contrasting color for the underlying tones. The brushes I use are a #10, #7 and #3 bright bristle.

STEP II Using the same brushes, I start blocking in the bright reds of the rooftops as well as some of the light-struck buildings. The paint is kept fairly liquid in the darks which may result in a few drips here and there, but that can always be cleaned up later. The pigment in the light areas is considerably thicker. I keep dipping my brushes in turpentine, constantly wiping them with tissue in order to keep the colors clean. I try not to dwell too long in one area, but rather keep moving around the canvas establishing color relationships over the whole picture.

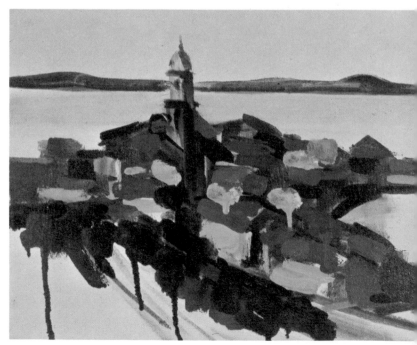

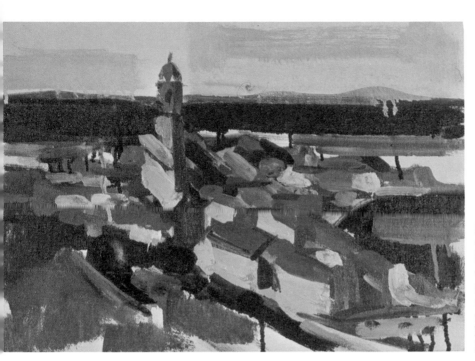

STEP III Now I add the darks of the water for added contrast against the buildings. It immediately sets up a violent reaction against the lights. I try a pink sky and further intensify the red rooftops. I start using very thick paint in the light buildings. Now the canvas is almost completely covered.

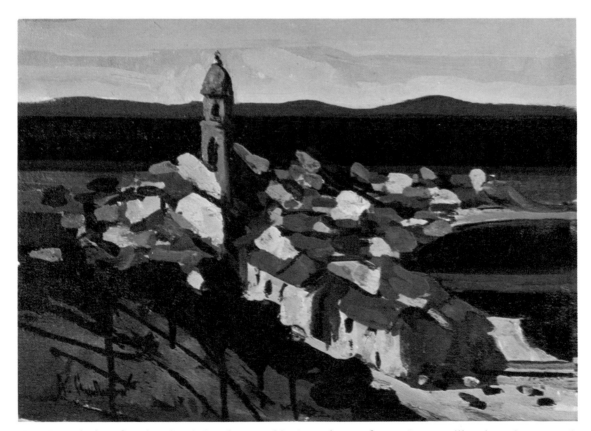

STEP IV It is time for a break. Sitting down and looking at the sketch and the painting, I try to figure out where the painting is taking me. Squinting at it from a distance, I decide to adjust the strips of water and the distant hills. I want strong horizontal strokes of the water in contrast to the blocky, thick strokes of the rooftops. I am still using the same brushes throughout, as I do not want to get tied down with detail. I try to keep the painting just as loose as in the beginning stages with a few refinements in the buildings and church tower. The foreground seemed too important so I simplified the area. With the color and values right, I call it quits.

25

PAINTING WITH A LIMITED PALETTE

VIEW OF WESTPOINT, MAINE.

This is a place not far from my home where I take my class landscape painting. John Marin used to paint here in the 20's, and I doubt if the place has changed much since that time. Within a few hundred feet there is a wealth of material which is typical of Maine fishing villages. The photograph was taken in the late afternoon. There were deep shadows on the rocks, buildings and distant trees. Since the subject is fairly limited in color, it seemed a good idea to use a limited palette to see how a few colors might create an entire picture. For this painting I have used white, yellow ochre, cadmium orange, burnt sienna and ultramarine blue.

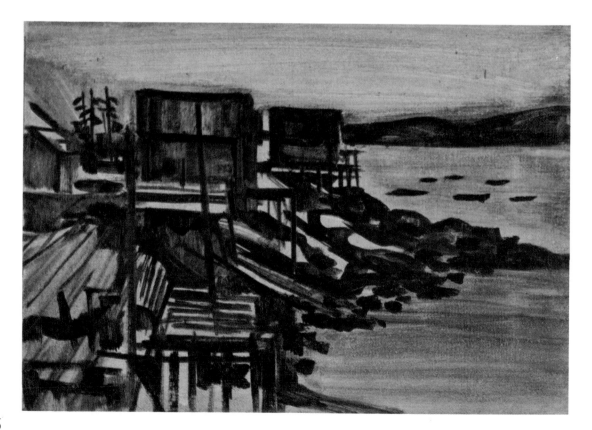

26

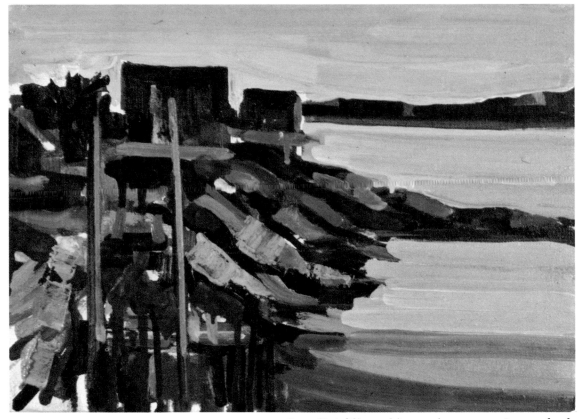

STEP I A tone of yellow ochre, burnt sienna and ultramarine blue was thinned with turpentine and rubbed on the canvas with a rag. The darkness of the tone depends on the amount of burnt sienna and ultramarine used. I kept it fairly light with the yellow ochre dominating. The brushes used in this "laying in" stage were flat bristle # 8, 5, and 3. I wanted to do the whole painting with just these brushes. The first brush stroke was a line about ¾ of the way up, establishing the horizon. Then I simplified the two buildings and massed them in with the rocks. The small boats and pilings were put in next. The complicated junk in the foreground was simplified into square shapes made by the actual size of the brush. No detail was drawn at this time as I was concentrating on an overall value pattern. With a complicated foreground such as this, it's a good idea to keep squinting in order to see all the elements as simple shapes and patterns. No white was used at this stage as I could wipe out any mistakes with a rag, leaving the toned canvas showing through, the tone acting as my lightest light.

STEP II Adding white to the orange, I started adjusting the value of the sky and water. In making the large, thick horizontal strokes, the small boats were obliterated, but they can be put in later when I get around to details. Keeping the paint fluid I further strengthened the darks using burnt sienna and ultramarine blue. A few drips will appear with the thin paint, but this too can be cleaned up in the final stages. Using some pure orange and yellow ochre mixed with a little white, I begin to establish the lights on the tall pilings and rocks. Here and there I used the flat side of the painting knife, mainly to enrich the textures. Because I have purposely limited the sizes of my brushes, it keeps me from fussing around with the unnecessary details. What I'm after is the total impression of the scene. I keep squinting to obtain this goal.

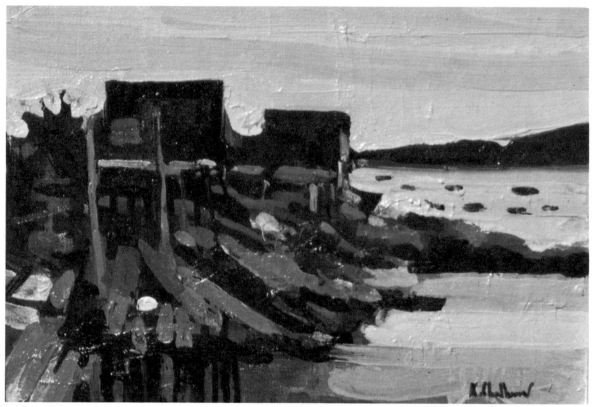

STEP III Final Painting

While the paint is still wet, I start building up more pigment in the light areas. Very little turpentine is used at this stage so that the paint will adhere well to the canvas. As a general rule it's not good to use turpentine as a medium for your final painting. Now I paint in the boats and add a few details for more interest. This is restrained to avoid making it look overworked. I strive to be as free in my brush handling at this final stage as I was in the beginning in hopes that the feeling of spontaneity will be retained.

MIXING GREYS

One of the most frequent questions that students ask is "How do you mix grays?" It is a natural question, unless you've been painting for quite a while, for you're likely to think grays in terms of house paints and how they might apply to a wall. In painting pictures, it's an entirely different ballgame. Whether you are painting atmospheric conditions or flat abstractions, the variety of grays you will be using are infinite. On page 30 you will find some mixtures I have found useful and they may prove helpful to you.

When mixing grays it is generally a good idea to use one cool color and one warm color or complementaries if you prefer, plus white. When you start mixing too many colors together, you are apt to end up with a muddy mess. A cool color means one that has some blue or green in it. A warm color has some yellow, orange or red in it. For instance, by mixing burnt sienna (warm) with ultramarine blue and (cool) with white, you will get a good neutral gray. You can make it considerably cooler by adding more blue or if you want a warmer gray, you add more burnt sienna. This same mixing procedure applies to all of the combinations, and I urge you to experiment with all of them.

There is one mixture I like that uses three colors: yellow ochre, alizarin crimson and ultramarine blue plus white. I call this my Vuillard gray because it has a lovely violet quality which approximates some of his grays.

A mixture of black and white is the most neutral of all grays, and is quite useful on some occasions. Some subtle grays can be obtained by adding another color, such as yellow ochre or alizarin crimson to this mixture. The possibilities are infinite.

The sketch of a fishing shack was painted with the grays on page 31. A careful look at some of these mixtures will show a match-up of some colors used in the painting. A painting knife was used in some areas to make the grays stand out more prominently. As in any color mixing, be sure to keep your brush clean by dipping it into turpentine and wiping it with a rag or tissue before you go from one color to another. Clean color requires clean brushes. I can't stress this point strongly enough. Unlike painting a wall, the slightest tint of color on your brush will change the whole complexion of your mixture.

Mixing and graying color is an important ingredient in almost every painting. Rarely, even when doing the most colorful subjects is it wise to use much color directly from the tube. Here are some of the mixtures from my palette needed to paint this shack.

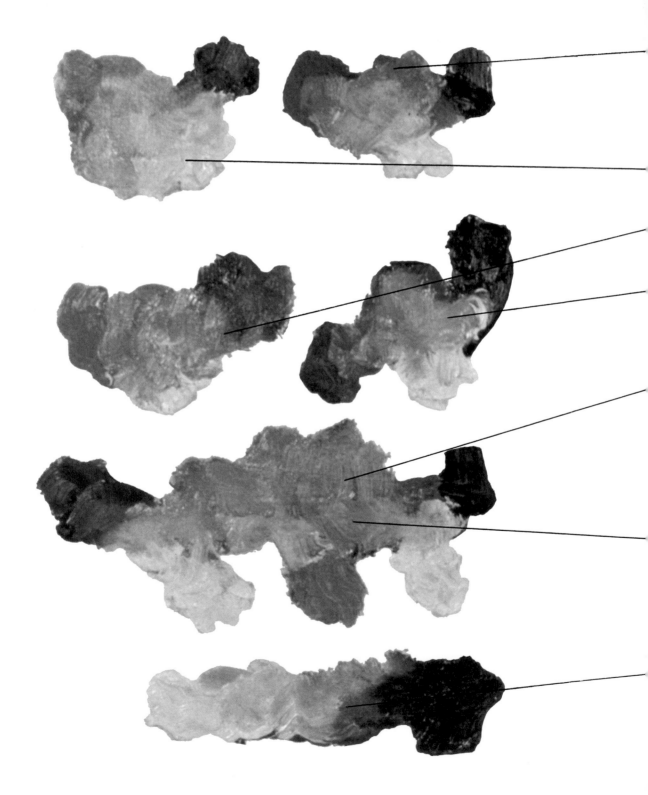

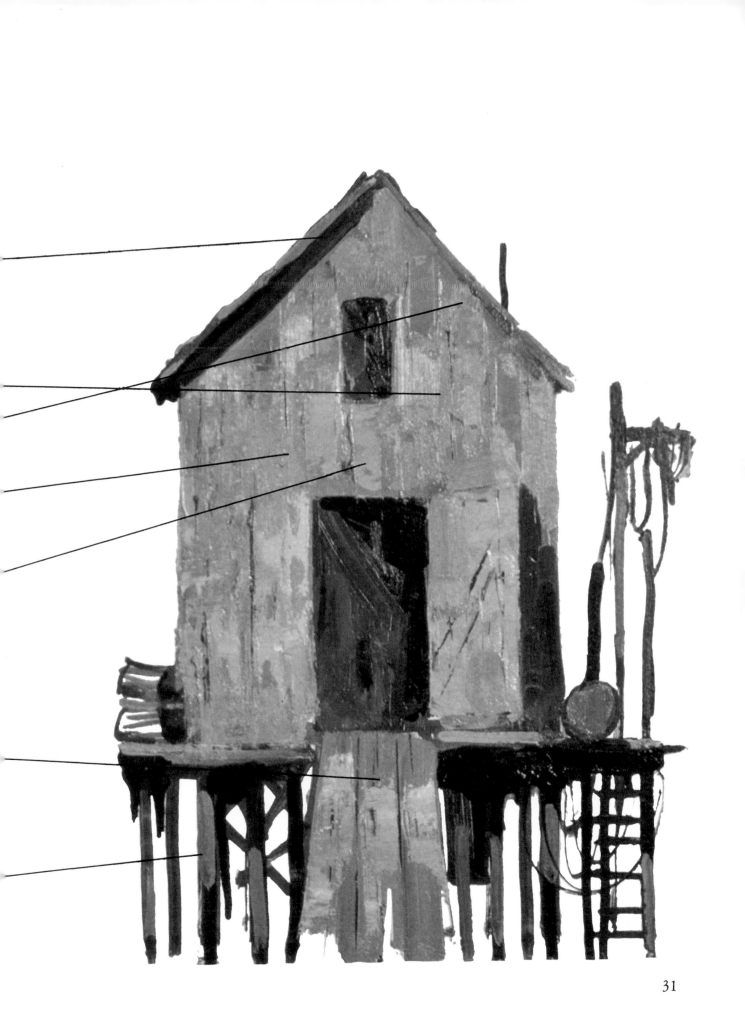

A final note on grays. . . . you'll find it worthwhile to look at reproductions of painters and books available in your local library. Look for the ''grays'' in their paintings and see how it might apply to your own work.

Here are some of my favorites: Velazquez—the master of them all. His grays in the large self portrait at the Prado in Madrid are magnificent.

Frans Hals is not my favorite artist, but his handling of ruffled collars and gray flesh tones is astonishing. Sargent studied him reverently.

Edouard Manet's small flower paintings and still lifes are absolute gems. There's a small still life of lemons on a pewter dish at the Pennsylvania Museum that is full of superb neutral grays.

Whistler and Sargent were not the greatest colorists, but they certainly knew something about mixing gray. The way Sargent painted gentlemen's doe-skin gloves is dazzling.

Maurice Utrillo used colorful combinations of grays in his French street scenes and beautiful pearly whites in the snow scenes.

From the early cubist paintings to the limited palette still lifes, George Braque made gorgeous use of black and white.

I could go on and on, but when you can, look up various artists and see if you can imitate their use of gray.

CHAPTER THREE
SKETCHING

A SKETCHBOOK HABIT

IT ALWAYS SEEMED a shame to me that sketches and drawings are never exhibited with paintings. Unless it's purely a show of drawings, it's rare that we have the opportunity to see the artist's sketches that led to the paintings. Perhaps it's because of their unfinished or fragmentary nature that galleries hesitate to show this work. Of course, the artist on his part might feel reluctant to exhibit anything other than completed works. I find sketches fascinating, and it's too bad we seldom see them until the artist is dead.

I got into the sketch book habit when I was a student in Paris. One of my favorite pastimes was to visit the Eugene Delacroix studio on that loveliest of all squares in Paris, the Place Fustembourg on the left bank of the St. Germain des Pres quarter. Among all the paintings, the things that impressed me most were the small watercolors and sketches he did during his travels to North Africa. Some of them were not much larger than four by six inches, but with his expressive line and simple washes these little sketches had more vitality than all the other paintings put together. Someone said that when you see an artist's drawing you see his signature. In a sense this is so. Looking at a sketch becomes quite personal, as though you were actually there enjoying the scene with the artist. There is an intimacy about a sketch a painting can never capture.

During a seminar a few years ago, Fletcher Martin was discussing a wall full of drawings he had recently completed on a trip to Mexico. One of the students asked him why he didn't take photographs instead of doing all those drawings. He answered that while a photograph might record the information he needed, with a drawing he could remember the smell of the place.

In most of my classes I ask the students to do a small rough sketch of the subject before they start their painting. Invariably I overhear the complaints, "I can't draw a straight line," or "It's easy for you, you know what you're doing." In fairness to both comments it would be foolish of me to expect anything but the most rudimentary drawing, but even that is a start, and if I can persuade a student not to feel ashamed at his efforts, it's a good beginning.

Drawing is an arduous discipline and may take years to master. During my earliest days in art school in California I had an instructor who methodically went around with a large marker at the end of a day's drawing lesson and made a big X mark over all our work. The purpose he said was to dissuade us from bringing our drawings home to our mothers. As a result none of us had much to show for our efforts that first year. Even though this treatment seemed brutal it served its purpose. It made us aware good drawing wasn't going to be accomplished overnight.

On the following pages are some examples of casual drawings and sketches from my notebooks in various techniques. Some of the drawings are rather hastily done from a sketch pad that I keep in the glove compartment of my car. Others were done at a more comfortable pace in my studio. Once you get the sketch book habit, it will rarely leave you or disappoint you. At odd moments during a ''dry'' spell in my work when nothing seems to motivate me toward a painting, going through my old sketch books will ignite a spark, leading to a whole new series of thoughts and ideas based on a visual experience that took place years ago.

SKETCHING EQUIPMENT

The drawing on the opposite page shows most of the materials I carry for sketching. Everything fits into the large canvas bag which is almost indestructible. It is a convenient and most useful bag, available in almost any store that sells camping goods.

Also I carry a type of small knapsack I found in an Army surplus store. It has handy pockets for sketch pads and will hold all I need when I am traveling light. Some airlines put out flight bags which are good for this purpose, as long as they have a lot of separate pockets for pencils, brushes, paints, etc.

The canvas folding stool is also a common item sold in stores from L.L. Bean to your local discount outlet. It has sturdy metal legs and folds flat into a light, manageable package.

The watercolor brushes can run into a lot of money because of the high cost of sable. Some pretty fair watercolor brushes are being produced in sabeline that is a little less expensive. A good watercolor brush will always come to a fine point once you dip it in water and flick it with your wrist. Ask the clerk to provide you with some water when you are buying these brushes so you can try them out. If the brush bows over limply and does not point up, don't buy it. For regular watercolors you will need the following brushes:

One #6 or #8 round sable, ox hair or sabeline.

One number #3 round sable for drawing fine details.
Look them over carefully and choose the ones you feel most comfortable with.

Paper and pads: For sketching purposes a couple of 11 x 14 inch Strathmore pads will be sufficient. A smaller pad 9 x 12 is the type shown in the drawing. I like

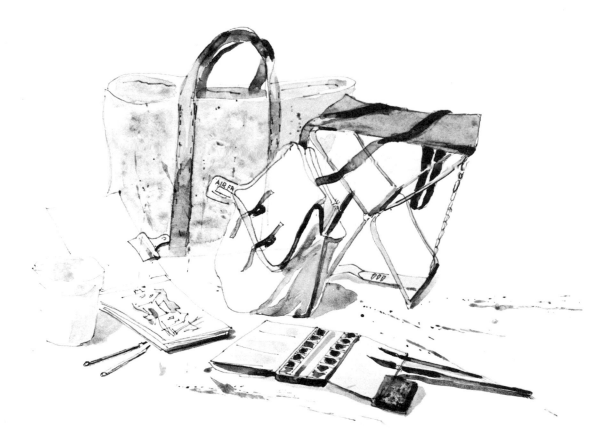

the heavy duty pads. They are usually made with stiff paper about 140 lb. weight suitable for pencil or watercolors. Look paper pads over in the store and get what suits you best. No need to get too fancy here, it is only for sketching.

Pencils and pens: Three of four soft pencils will do. I like the charcoal and carbon pencils for rich darks. These run from B to BB to 4B. The Eagle draughting pencils are good for general sketching and will not get as dirty as charcoal. I find the Pentel pens good for general pen drawings. They wear out easily, however, so I usually carry a pen holder with various nibs for finer work. Not shown is a bottle of India ink. Be sure the top is on tight!

Watercolors: Shown here is the Winsor & Newton watercolor box with block colors which can be replaced. Most people prefer the tube colors which are actually better for general watercolor work. I like this box for sketching purposes, as most of my watercolors are very casual and are not what one would think of as a finished watercolor painting.

A sponge, a plastic water container and a box of tissues conclude the list. The important thing is not to burden yourself with too much heavy equipment. If you are going to be doing large watercolors then you would need a drawing board, but for sketching purposes a small pad on your lap is all you need.

SKETCHING TECHNIQUE

On the following pages you will see a variety of sketches done in various mediums, picked at random. These drawings and sketches were done over the years on trips on the Maine coast, some in Europe, and some in my studio. The lithographs were printed in a local workshop with my good friend, John Muench, one of America's finest lithographers. The point in describing these techniques is to urge you to experiment with various mediums. If you find working with a charcoal pencil is too messy, then try pen and ink or a harder lead pencil. Sometimes a mere line drawing will suffice in getting down your basic reactions to the scene in front of you. Keep experimenting until you feel at ease with whatever medium you choose. Because the cork tops on India ink bottles are not totally reliable, it would probably be safer to keep the pen and ink work at home. Nothing can be more disastrous or more discouraging than a leaky ink bottle spoiling all your equipment. The same can be said of a leaky watercolor tube. To be safe, carry these items in a plastic container.

As with any discipline, good drawing can only be obtained through constant practice. Not all of the illustrations on the following pages are what I would classify as good drawings. Some are brief sketches which only serve the purpose of recording the information I wanted about a particular subject. Other drawings, done in my studio, constitute more search and development because I was able to become more exploratory in a comfortable indoors situation.

LOBSTERS
Pen and Ink Wash

LOBSTER — A. CHADBURN
9 Aug. 77.

Invariably, before these marvelous creatures end up in the pot, I will place them on the floor and do drawings of their incredible crustated forms. This drawing was done with India ink diluted with water on 140 lb. smooth Fabriano watercolor paper. A fine pen was used for the initial drawing with the large masses being brushed in as I went along. The deeper darks were added while the paper was still damp, creating a softer edge. Some splatter was used for texture by tapping the brush against my fingers.

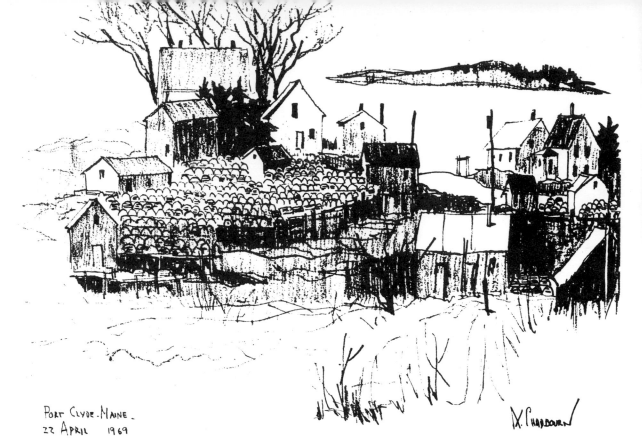

PORT CLYDE, MAINE.
22 APRIL 1969

X. Chadbourn

PORT CLYDE, MAINE

This is a fishing village from which you can catch
the mail boat to Monhegan Island. It is a pleasant
place that has not been overrun by tourists. Within a
radius of half a mile there is enough material to fill a
stack of sketch books. This was done with a Wolff
Carbon 2B pencil on Strathmore paper.

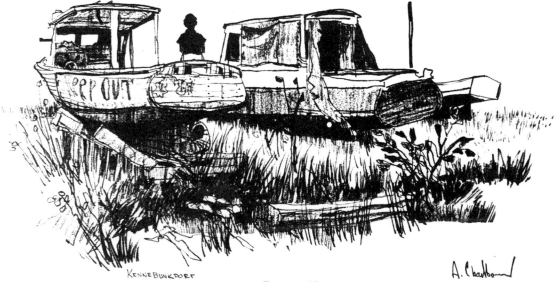

KENNEBUNKPORT
MAINE - 13 AUG '62

A. Chadbourn

BOATS—KENNEBUNKPORT, MAINE

This drawing was done some years ago while on a
vacation. My son obviously did not pay any attention
to the sign on the side of the boat. Old, much-used
work boats have a lure and fascination for everyone. I
used a Wolff Carbon 3B pencil on Strathmore paper.

38

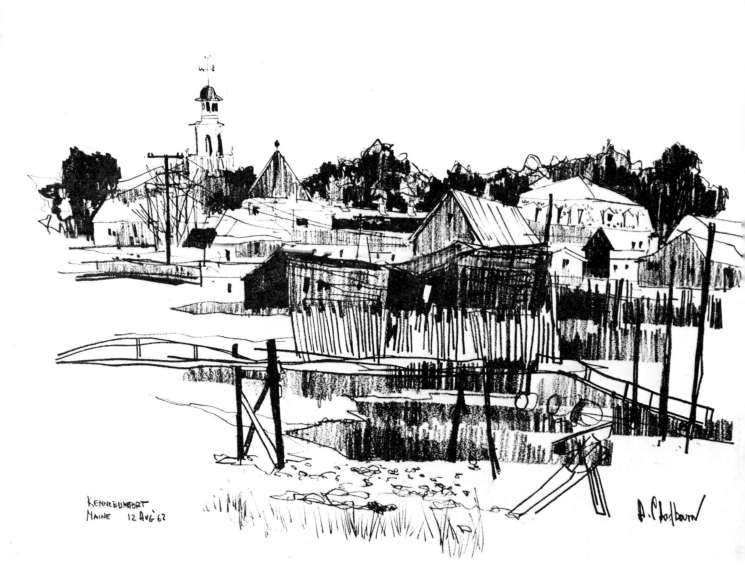

KENNEBUNKPORT
MAINE 12 AUG '62

KENNEBUNKPORT, MAINE

A lot of white space was left in this drawing to form a vignette. I used this drawing as a basis for several paintings. I was not concerned about the actual correctness of all the buildings, as they would probably be moved around in the final painting anyway. I only picked out the shapes and patterns which formed the essence of the place. This was done with a Wolff Carbon 2B pencil on Strathmore paper. A finished oil painting from this sketch is shown on page 56.

LITHOGRAPH

For those who haven't tried it, I do not think there is a more inviting surface to draw on than a finely ground, blue-gray surface of a lithograph stone. The surface and density of the stone are most conducive to experimentation. Perhaps this is why lithography is often called a painter's medium. In the hands of an expert the stone can speak a beautiful and unique language. Effects are achievable with it that are impossible in any other graphic medium.

I am fortunate to have John Muench as a neighbor and friend. I have used his workshop several times and each time it has been a new and rewarding experience. With the intense revival of this art form, with print clubs and workshops sprouting up all over the country, you might find these facilities available to you. They are often connected with continuing education programs offered in colleges or universities. Sometimes they can be found in small private print shops. If you enjoy any form of drawing, it would be worthwhile to check into it.

Most laymen are confused about prints and reproductions. A reproduction is exactly what the term implies—a copy of an original painting, drawing or print, not necessarily the same size as the original. Such reproductions are usually accomplished through a photoengraving process. A fine print (lithograph, etching, serigraph or woodcut) is an original work of art conceived and executed by the artist as a unique and original statement. It is printed in a limited edition on a fine paper and personally controlled by the artist.

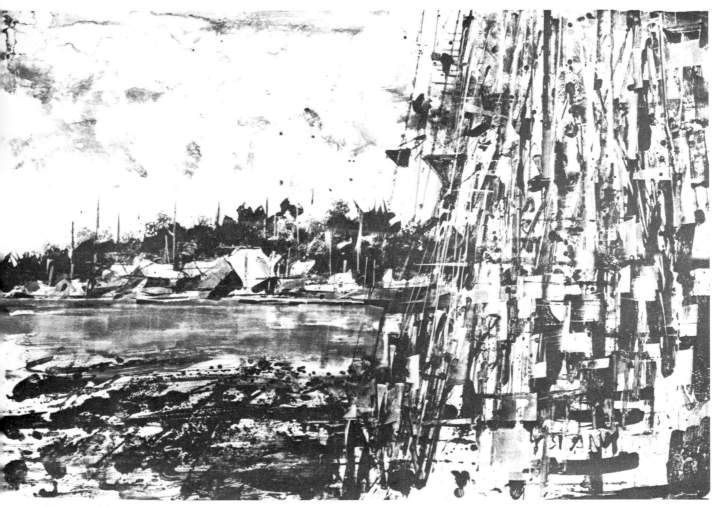

COASTAL VILLAGE, MAINE
Lithograph 20 x 24 inches

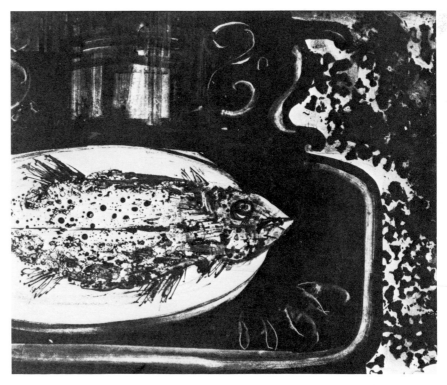

FISH ON PLATTER
Lithograph 10 x 12 inches

Lithography is an exact and somewhat complicated medium requiring a number of procedures to master. Both of these lithographs were printed in John Muench's workshop, and since he did much of the technical work, it would be unfair for me to describe all the steps required to produce these prints. Each time I do a lithograph I learn something new. It is an exciting creative process.

41

There is much misinformation and misunderstanding about watercolors. How all these myths got started is beyond me, but for your own peace of mind, I would not worry about imaginary problems. Watercolors are really no more difficult to handle than oils; the big difference is that you use the white paper for your whites, and therefore you have to do a bit of planning ahead. The idea that you cannot correct mistakes is nonsense. Winslow Homer, master of this medium, scrubbed out areas constantly; so do Dong Kingman and many other watercolorists.

Since this book deals primarily with oils, I will not go into the technical aspect of watercolor painting. However, there are many good books available if you want to pursue it. I use watercolors primarily as a sketching vehicle and rarely get into what would be considered a finished watercolor. Rarely do I paint to the borders of the picture and try to work for a complete composition.

I usually use a watercolor sketch pad, a half sheet of Fabriano 140 lb. smooth paper or the Arches 300 lb. rough. I have one expensive #12 fine sable watercolor brush and a #2 sable for small details, and I have a small butcher's tray for a palette. I also use the small Winsor & Newton paint box with the block colors. I keep my materials down to the bare minimum.

THE CASINO—MONTE CARLO.

In spite of all the reconstruction going on in Monaco with the old villas and hotels being replaced by skyrise apartment buildings, the Casino remains a glittering example of the faded elegance, synonymous with the name of Monte Carlo. I did this sketch from the gardens of the Hotel de Paris just across the street from the Casino. It was a few days before the Grand Prix when the road would be barricaded to give way to the zooming racing cars.

The sketch was drawn with a 2B pencil first. Then the light washes of the sky and building were added with plenty of water. Generally I do not erase any pencil lines that show through from the original drawing. Since it is a sketch, the pencil lines seem to be a natural part of the water color. Next I painted the copper green roof and palm trees, and only added enough detail to describe the objects without getting too fussy. The cast shadows and the dark accents around the doorway were added, plus some splatter in the foreground, and the sketch was completed. All of this was done with one brush, a Winsor & Newton Round Sable #12. A good, big brush will cover large areas easily and will also "point up" for finer detailed work.

HARDWICK, VERMONT

This is about as close as I get to what is considered a finished watercolor. Because it is a snow scene I wanted to use the white accents of the paper for snow. First, I layed in the light blue washes of the middle values, then some of the light warm tones of the sun-struck buildings. In this way I could control the overall design with just the middle values and the shapes of the white paper. Next came the darker tones of blue which were painted over the light washes. The darkest darks of the buildings and trees were painted in, still holding on to those light shapes of pure white paper to obtain the effect of snow. I like the complicated pattern of New England villages; during the winter, with the absence of foliage, the geometric shapes become more evident.

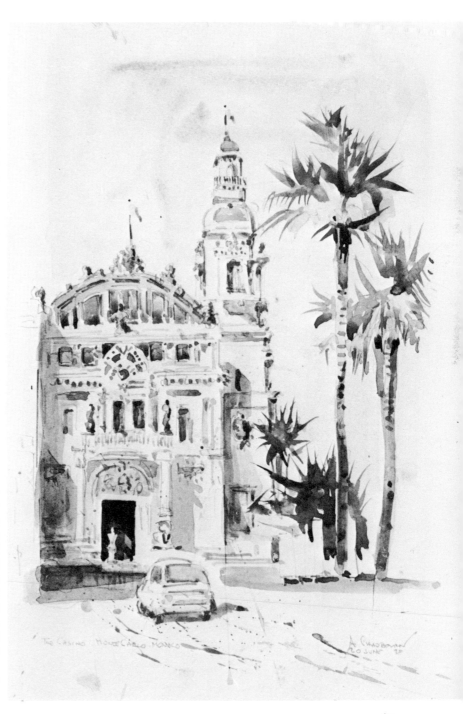

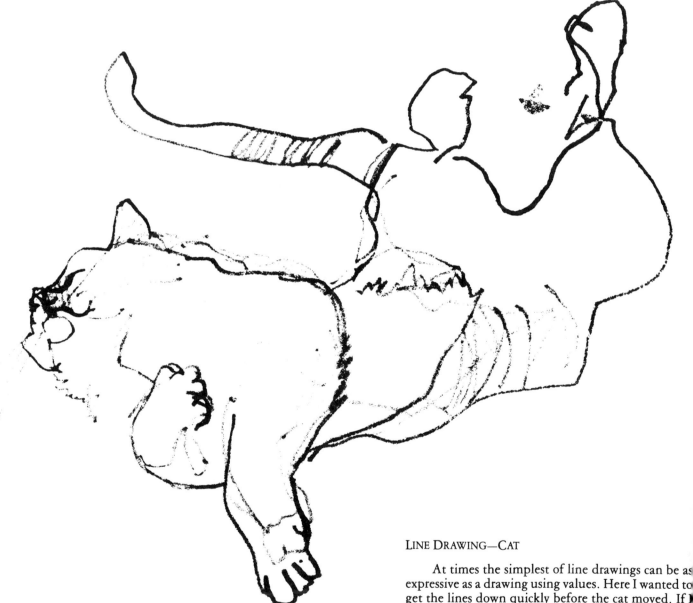

LINE DRAWING—CAT

At times the simplest of line drawings can be as expressive as a drawing using values. Here I wanted to get the lines down quickly before the cat moved. If I had spent the time to build up a lot of shading, the cat surely would have moved. Gesture sketches such as this can be fun. It requires practice to get used to putting down your initial responses quickly. For this type of exercise, keep your pencil on the paper without lifting it from the surface, and keep your eye on the subject. Nicolaides in *The Natural Way to Draw* has some good ideas about this type of drawing. I highly recommend it as a way of learning to express the essence of a subject.

44

EW OF MENTON, FRANCE
ntel pen on Strathmore

This is the last town on the French Riviera before
ming to the Italian border. It is a pleasant, peaceful
ace. On my walks through this lovely pink and
hre town, I made a number of sketches, some of
iich I later used as the basis for paintings.

ANISH VILLAGE, SINEU, MAJORCA
ntel pen on bond paper

In most of the predominantly Catholic countries
ch as Spain, towns and villages are invariably dom-
ated by a hugh church or cathedral looming over
e cluster of red tiled roof tops. The forms and
apes of these villages have always attracted me, par-
ularly when seen from the plains. When I made
is sketch it was late in the afternoon. Looking into
e setting sun made a silhouette of the buildings
th only one or two rooftops catching the light. A
ugh drawing like this leads to countless composi-
ons by varying the position of the buildings and
anging the value pattern. I generally start my draw-
gs with a used Pentel pen which will act as a gray.
ien, with a fresher pen and by bearing down harder
an obtain my desired darks.

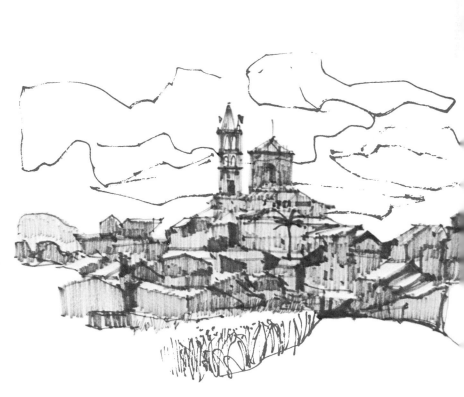

45

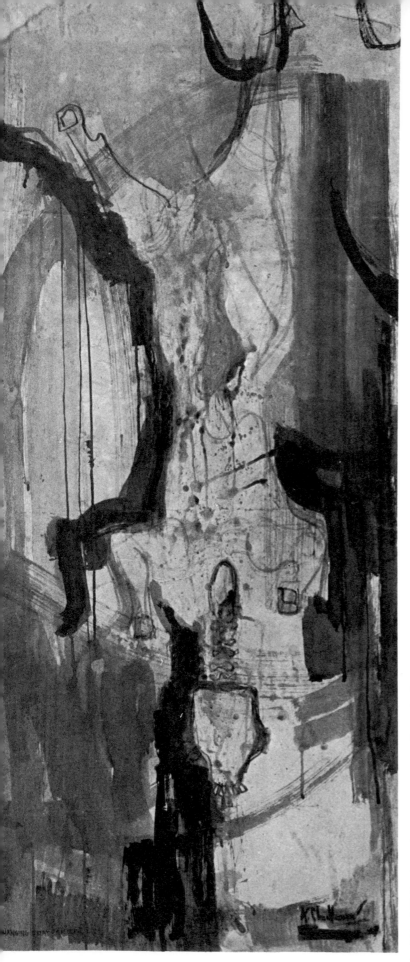

DEAD GOAT—HYDRA, GREECE

Some years ago I was fortunate to receive a Tiffany Foundation Grant to live and paint in Greece for an extended time. I was given a large studio by the Beaux-Arts on the island of Hydra not far from Athens. It was a marvelous opportunity to study art and observe the local culture. On more than one occasion the two subjects overlapped. Here is one example.

Like all Greeks, the Hydriotes are very fond of lamb. When lamb was not available they cooked goat in a variety of ways, from stews to roasting on the spit. During one of the many feasts I enjoyed with my Greek friends, I was asked to keep a slaughtered goat in my studio, hanging on a hook until they were ready to prepare the feast over an open fire and spit. All painting stopped, and for the next two days I produced sheaths of drawings similar to the one shown here. Doing large drawings on a big roll of paper can be good exercise both physically and mentally. Working at a large scale will automatically induce you to use larger brushes and freer techniques. It is the only way to feel more comfortable when working on a six-foot sheet of paper. I used house paint brushes from 1 inch to about 3 inches wide and a broad nibbed pen. The drawing was done with diluted India ink.

Obviously not many of you will be able or want to have a dead goat hanging in your studio, but there are other animals which are less gory, but equally fascinating to draw such as chickens, rabbits or game. The impulse to draw or paint hanging meat has found interest for artists since Rembrandt's time. There must be something universal in its appeal, even though the subject is not for the squeamish.

DRIED COD

Pen and ink wash drawing on Fabriano 140 lb. paper.

Although much smaller in scale, this drawing of dried cod has some of the same feeling as the hanging goat. Dried cod, the main staple of the early New England sailors, are found in fishing shacks up and down the Maine coast. Sometimes they are strung on lines or merely placed on boards to dry in the sun. They make interesting shapes to draw and their delicate network of bones, like exposed rib cages, make for a nice contrast to the bold brushwork in the background. The crucifix motif was not intentional when I started this drawing, but it ended up that way because of the cross pieces of wood on which the cod is nailed.

47

BUTCHER
Watercolor 24 x 18 inches
Collection of F. Parker Reidy, Portland, Maine

This was done from photographs taken about four in the morning around Haymarket Square in Boston. There is a great deal of activity in the markets at that time when the produce arrives. Large carcasses are rapidly chopped up and prepared for display. With such confusion it would be impossible to do anything but a quick sketch. At such times the camera is the most helpful. After concentrating on the luminous shadows of the head, I used the white paper for the apron and let it be part of the design of the background. Note the original pencil lines of the drawing show through on the arms and head.

48

BUTCHER · HAYMARKET · BOSTON

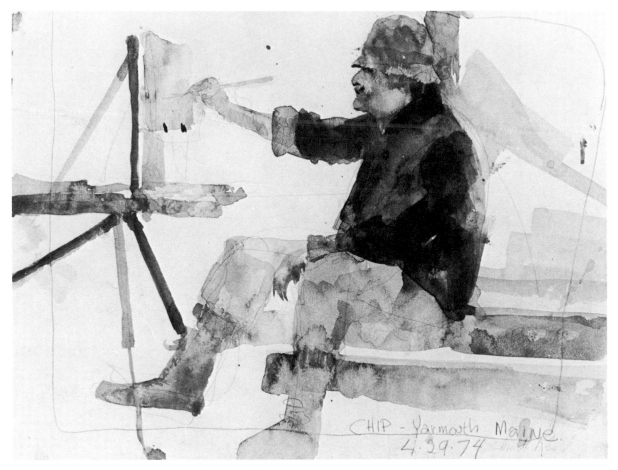

SKETCH OF CHIP PAINTING—by Charles Reid
10 x 14 inches—Watercolor on Fabriano paper

This is the way a watercolor should look: spontaneous, transparent and, like most of Charlie's work, seemingly effortless. Note the light values on the arm, easel, and boots which have little modelling, yet the shapes explain themselves clearly. In the dark areas of the jacket and head, a lot of wet-in-wet was used and colors lifted off with a tissue. Somehow these areas never look overworked or dirty. The casual line drawing which helped to establish the original pose has been left as part of the total design. When you draw this well, there's no need to use an eraser.

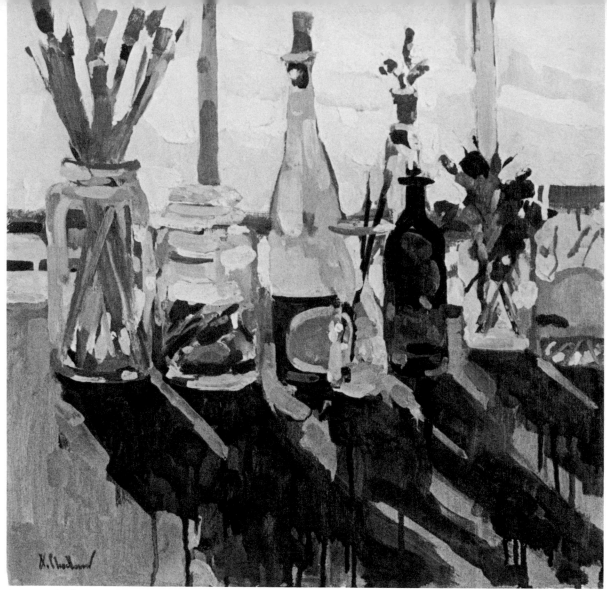

BOTTLES IN STUDIO WINDOW
18 x 18 inches — Oil on Canvas
Courtesy Barridoff Gallery, Portland, Maine

CARBUR'S RESTAURANT ►
60 x 40 inches — Oil on Canvas
Courtesy Barridoff Galleries, Portland Maine.

Bottles against the light are fascinating. I always keep a variety around my studio and stick them in my still lifes when I feel they fit the need. In this case I put a number of assorted bottles against my studio window on a bright red table top. I was particularly interested in the shadow patterns on the table. As I glanced at the bottles I became aware of the jumble of prismatic shafts of light coming through the glass, forming a series of geometric shapes against the light. To capture this effect I forced the thick and thin white and off-white paint rather than define the accuracy of the forms. Although it probably does not look it, I spent hours repainting the globs of paint which were so close in value in contrast to the dark, drippy cast shadows on the table. In order to accomplish an impression of a given scene, it is important not to dwell too long on any specific object; move over the entire canvas putting down fragments of objects. Gertrude Stein once advised a young painter, ''Look at nature, then turn your back on it and paint.''—not an easy thing to do, but it is worth remembering.

Hanging plants can turn an otherwise mundane restaurant window into a delightful subject matter to paint.

This is a restaurant in Portland, Maine, with windows festooned with hanging plants. The pattern of the greenery facing the light caught my eye during lunch one day, and I returned later to make some sketches. Had I been more ambitious I could have set my easel up and painted on the spot after the rush hour, but I find it easier to solve problems in the comfort of my studio. In the winter there was a blinding yellow light making a brilliant contrast against the cool blue greens of the plants and their long violet shadows. The only warm accents were on the red chairs and copper urns in the windows. I am particularly fond of these old, renovated buildings with their tall, curved windows and graceful mouldings reflecting the faded elegance of another age. The Victorian light fixture and wooden electric fan helped complete this aura.

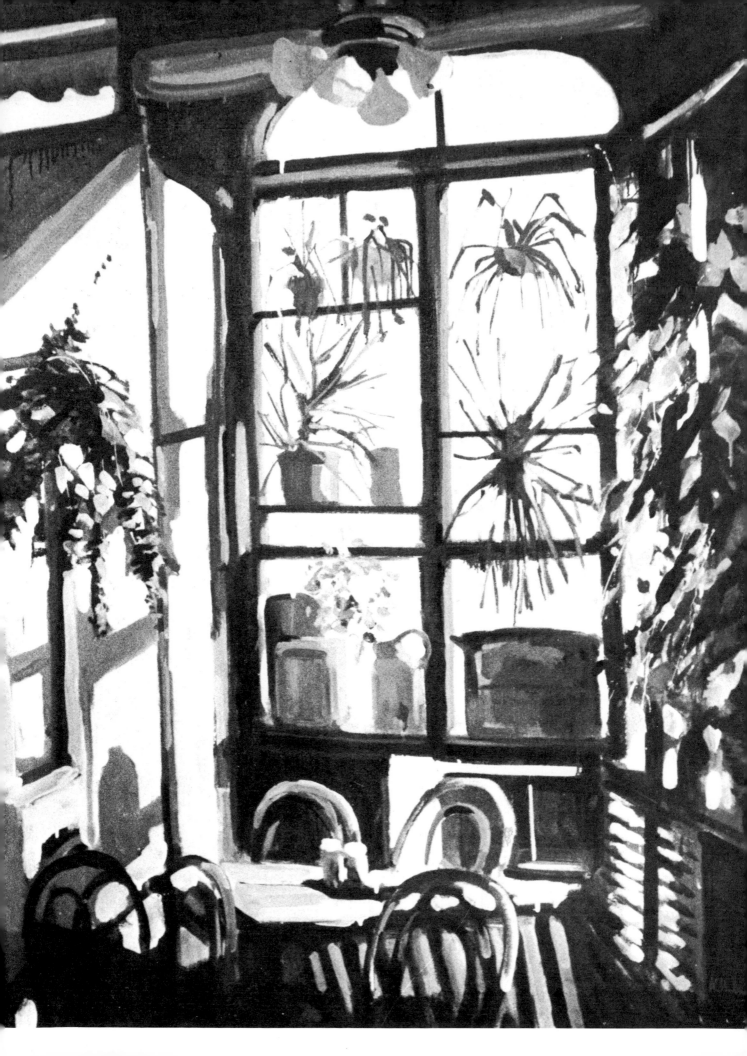

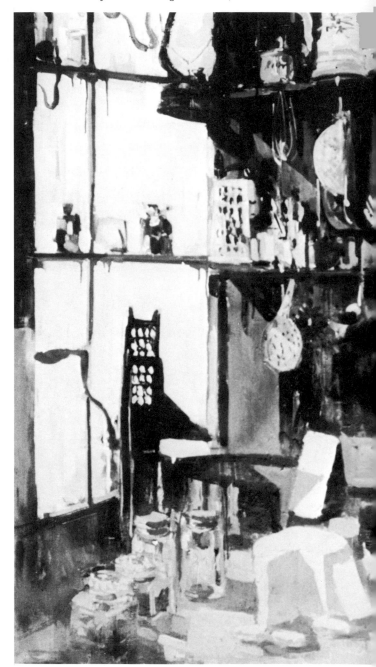

An old photograph of a cheese shop in Vermont was the basis of this painting. My own kitchen utensils on the shelves were added. When working from photographs, don't feel obligated to copy them precisely. If you can come up with your own arrangement, so much the better. Familiarity with objects such as those you use every day will make the picture easier to paint. The control of the size and shape of such forms becomes almost automatic. That is why so many objects I'm fond of keep reappearing in paintings. Although subject matter plays an important role, my main concern in this scene was painting light.

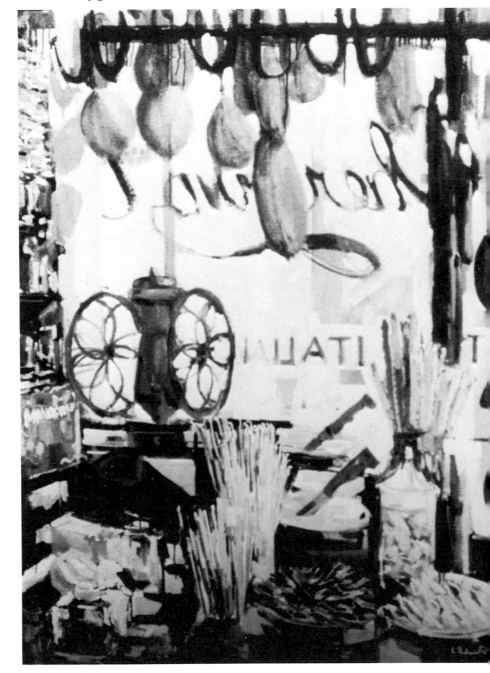

The streets of the Italian North End of Boston exhibit an endless variety of food stores full of all the good things associated with Italian food. I like painting clutter, and these stores abound in it. They also smell marvelous, with the aroma of the freshly ground coffee, the hanging cheeses, or the vats of fermenting olives. They excite my gastronomic senses as well as my optic nerves. By working from a number of sketches, I can pick objects at will, putting in and taking out the shapes to give the viewer the same enthusiasm I have for the scene. If I lived in Boston I'm sure I'd never go near another supermarket. The Pop artists may like it, but I cannot get excited or moved by a shelf full of Wonder Bread.

CHAPTER FOUR
SOME PAINTING PROBLEMS

PAINTING AGAINST THE LIGHT

ONE OF THE most difficult yet rewarding experiences for me is painting objects against the light. I don't know what initial impulse got me absorbed with this problem, but I've been intrigued with light coming through windows for the past thirty years. Perhaps it's because the light keeps changing and something wonderful happens when simple objects like pears, apples and lemons are seen against the light. They take on a whole new character. I can't analyze just what causes this metamorphosis.

The next time you set up a still life arrangement try moving it in front of a window and see what happens. The whole arrangement, enveloped in light, will take on a totally different appearance. The objects generally appear darker than the light around them. Also, the cast shadows will be considerably darker than the surface on which the fruit is standing. Usually this makes a soft edge transition from the object and the cast shadow, creating a mysterious deep color relationship which is fascinating, but not easy to paint. I think it's when you're observing and adjusting the dark values to the bright lights that the painting becomes endowed with a light of its own. Depending upon what I'm painting, it may take me several hours to obtain this special quality of light, but I feel the struggle is worth it.

PAINTING TOWNS AND CITIES

When I first started doing landscapes in California shortly before World War II, I tried doing a version of El Greco's "View of Toledo" using the city of Los Angeles as a model. Having seen a reproduction of this famous painting I thought it embodied just about everything a good landscape should have, including all the drama that so appealed to me at the time. I remember doing sketches of the city from a nearby hill where I could get the same sweeping view (this was before the freeways) and instead of using a cathedral, I used the then new Civic Center with the City Hall as the focal point of my masterpiece. I stretched a huge canvas and worked on those stormy clouds for weeks trying to get the same dramatic effect in hopes that it would bowl over the viewer with its impact. Unfortunately, it did not quite work out that way

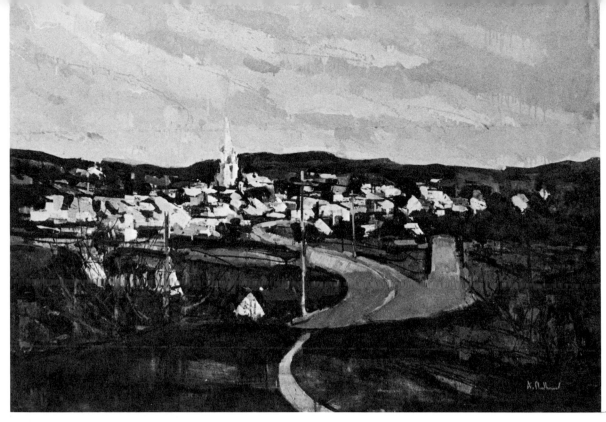

VIEW OF MACHIAS, MAINE
40 x 50 inches — Oil on Canvas
Courtesy of Barridoff Galleries, Portland, Maine

I did a watercolor of this scene while sitting in the back seat of my car during a rain storm. By the time I finished the painting, the sky began to clear and a dramatic light effect occurred, changing my initial thinking. I switched over to a sketch pad and quickly jotted down notes about the angles of the clouds serving as a foil against the strong directional movement of the road. I made the finished painting weeks later in my studio.

When painting landscapes directly from nature you must be willing to put up with the various whims of weather and atmosphere. What you paint in the morning will never look the same in the afternoon because of the changing light. And seldom does the weather stay the same from day to day. All of these are good reasons to lock up your vision of the scene in your brain if you want to capture a specific moment in time. You could do what Monet did and take out six or eight canvases with you and paint the same haystack scene over and over for each changing phase of the sunlight. As much as we are indebted to the great man's search for color in light, I don't think I could make it past the third haystack.

and the painting, having collected dozens of rejection slips from local exhibitions, ended up as most of my failures still do, in the trash bin.

Years later I visited the El Greco Museum in Spain and was as much in awe as I am today of this breath-taking painting. On close scrutiny I realized it was impossible for El Greco to have viewed Toledo as he painted it; such a vantage point does not exist. Most of the painting is sheer imagination, although I am sure it captures much of what Toledo looked like in the sixteenth century. Ruminating about what went wrong with my painting I realized I had learned another lesson. And it was quite simple. I tried to tackle a subject that was far and away beyond me. In spite of my good intentions, I was perched on a hill with all of Los Angeles County spread out at my feet, and I had not the slightest notion of how to distill such a panorama, let alone solve the multiple problems of perspective. It was too ambitious a project for my limited skills. I do not want to discourage anyone from trying something they feel is difficult to paint, but there are times when our appetites for various subjects should be curtailed. Paradoxically, I painted a ''View of Toledo'' while on a visit there recently. No apology needed to El Greco this time as I included no stormy

VIEW OF KENNEBUNKPORT, MAINE
30 x 54 inches — Oil on Canvas
Collection Mr. & Mrs. William Ballard, Greenwich, Connecticut

This picture was painted from watercolors and sketches done several years before. (See page 38.) In this semi-abstract version I toned the canvas first with a cool gray mixed with ultramarine blue and burnt sienna. A few broad strokes of the palette knife established some of the off-white geometric house shapes and pilings in the foreground. Next came the darks worked in very broadly with a 3-inch house painter's brush. Cool violet colors were used through the distant trees and foreground areas. At this point there was enough pattern suggested, so I could start draw-

ing with a brush over the forms. The drawing and painting were done simultaneously in order to lose some shapes and redefine others. I was purposely not aware of any light source, as I wanted to keep the painting reasonably flat. A certain amount of depth would be achieved by overlapping shapes. The painting has a rather somber, cool effect with the white and off-white areas of thick paint in the buildings adding contrast to the subdued grays of the darks. Detail was held to a minimum as I wanted to concentrate all attention on the total impact of the scene.

clouds or perspective. It is possible, however, some of my earlier, frustrated ambitions were at work without my knowing it - see page 120.

In time I got around to the museums of Paris and saw what could be done with simpler views of buildings and architectural themes. Street scenes by Utrillo or the roof tops of Cézanne made me aware of the beauty of this type of subject through a more personal and intimate vision. It became clear to me you do not need a vast, panoramic view to make a town or cityscape interesting.

Lawrence Durell said he was fond of Greece because he always felt someone had walked on the earth before him. In many ways I feel the same way about New England.

Leaving the historical connotations aside, I like the way towns and villages seem to fit their surroundings. To be sure, our land is slowly being covered with black

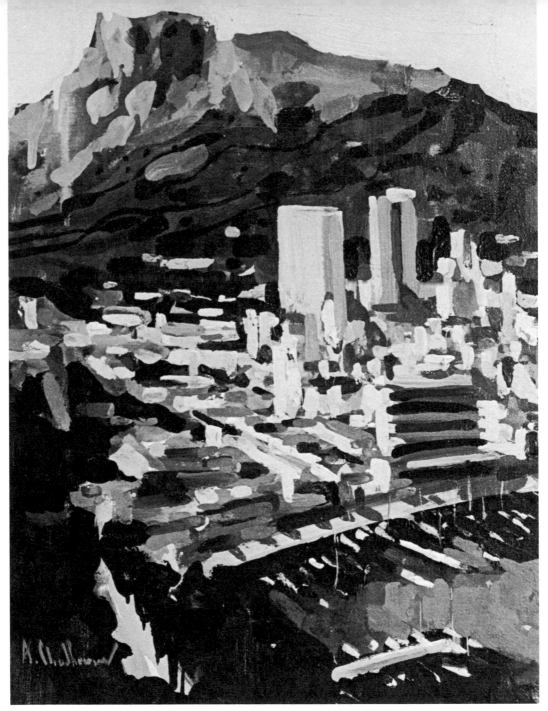

VIEW OF MONACO HARBOR
16 x 10 inches — Oil on Canvas
Private Collection—Monaco

This is a view of Monaco as seen from the palace grounds above the harbor. As you can see, the high-rise buildings have taken over most of the old villas, which were awful yet splendidly garish, and so reminiscent of the twenties. I painted this small painting in one sitting during the late afternoon which gave a warm, yellow light to all the buildings. Some of the yachts in the harbor seemed the size of the QE 2. You could watch the rich lolling about the decks, being served by little men in starched white jackets. I was reminded of a remark by Somerset Maugham, "Monte Carlo is a sunny place for shady people."

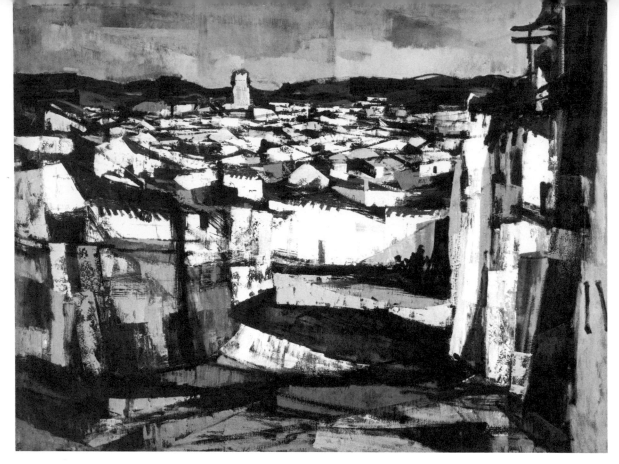

SPANISH VILLAGE
40 x 50 inches — Oil on Canvas
Henry Ward Ranger Purchase Award, National Academy New York City
1968

This semi-abstract version of a Spanish village was done twenty years after the original sketches. I have rarely been able to paint off the top of my head like so many of the pure abstractionists. It is important to me to keep my sketches, as they often act as a springboard to painting ideas. In this picture I used a reasonably limited palette with lots of browns and ochres plus white and black. Black, to me, is a very Spanish color which was so often used by the great painters of Spain: Goya, Murillo, Zurbaran, Velazquez and, of course, Picasso, who used it all the time. The light and shade in this picture was used primarily as an abstract pattern, rather than describing any condition of light.

macadam. At times I fear the true sign of the era is well illustrated by that ominous trade mark showing an upturned paint can pouring over the globe with the logo "We Cover the Earth." Fortunately, our "shoporamas" have not yet completely extinguished the hills, mountains, and the sky.

When you do a lot of sketching you become aware of the scale of objects, and I am sure this has something to do with the way the New England mountains and hills fit into the sketch pad. One of my first instructors, Henry Lee McFee, a solid painter, and the man who first introduced me to Cézanne, once said you never see a painting of the Alps or the Grand Canyon at the Louvre, and to be sure, you don't. The same could be said of the Tate, the Met, the National, the Frick, etc.

Because I find myself overwhelmed with some scenery I find it essential to do a drawing or a sketch first. It is much easier to resolve three-dimensional reality with problems of perspective and changing light by first reducing them into a simple flat pattern first. All of the paintings that are reproduced here were done in my studio from sketches made on the spot. I only started working this way after spending a good part of my life painting directly from nature.

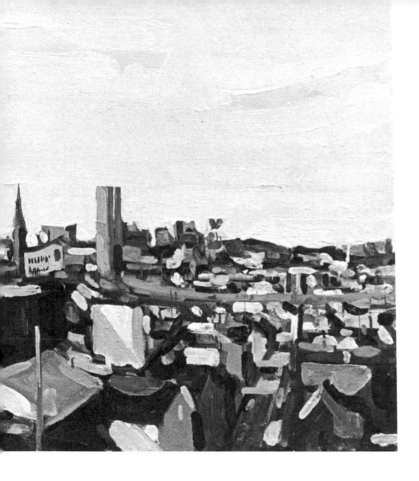

VIEW OF PORTLAND, MAINE
20 x 20 inches — Oil on Canvas
Private Collection, Portland, Maine

I've done six paintings of this view of Portland from a vacant lot on top of a hill overlooking the city. I started by doing dozens of small, rough sketches like the one below, made some color notes and then painted from the sketches in my studio. Had I done the painting on the spot, I know I would have included a lot of unnecessary details. The early morning light, with an off-white pink sky contrasted with the deep brick reds of the buildings, appeals to me. As you can see, the picture is divided almost, but not quite, in half. Some of the tall verticals were exaggerated, but my main purpose was to paint the cluttered pattern of light and dark which caught my eye in the first place. I find a square canvas a challenging compositional problem.

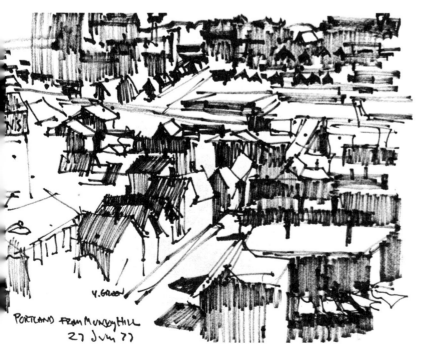

PORTLAND FROM MUNJOY HILL
27 JAN 77

Pentel pen on bond paper.

This rapid sketch is typical of my short-hand notes when I'm drawing from the inside of my car. It was late afternoon and the temperature was dropping well below zero. Although the light source is reversed, and some of the buildings are cropped at the top, it was enough information for me to start my painting at home.

59

When my classes get bored painting still lifes with the usual objects such as apples, bowls of fruit, wine bottles and pieces of cheese, painting interiors makes a good change of pace. Since I'm prone to casual or "lived in" set-ups, I use a corner of my studio with the potbellied stove, or my working table with all the assorted jars and boxes of paint tubes, or sometimes just a simple window with some flowers on a table. When we get more elaborate, I set up whole dining room scenes with a set table including food on a platter. For this kind of arrangement, it's handy to have a screen around or a moveable door that can help divide the space into corners to prevent the need for painting the entire length of the room. If the door idea looks too empty, try tacking some wallpaper or fabric on it. The word here is ambience. Try to give your interiors an intimate quality by creating theme, move your easel fairly close to the scene. This will open up new vistas so you break up space in an interesting way. If you have room, try painting a corner of your kitchen, bedroom or sitting room. Make sure to try several little thumb nail sketches before you start your painting. The tendency of most people is to take in too much, making the objects in the picture miniscule. Inevitably your lighting conditions are going to be less than perfect, so it helps to move in close enough to your subject so that you can see the important elements clearly.

When I think of interiors, my mind goes immediately to Vuillard and Bonnard who caught that magic of French bourgeois life better than anyone. All that busy wallpaper and overfurnished rooms must have been a bit suffocating to live in, but what gems they are as paintings. It is interesting to note that once Vuillard became successful and could afford to move out of his mother's dress shop, instead of choosing a large white-walled studio, he rented a small, modest apartment with the same type of wallpaper and funny sinks. No doubt he was more comfortable in such an environment.

In 1947 I took a trip to St. Remy de Provence to visit Van Gogh's asylum in that lovely 13th century monastery of Saint Paul. The thing that impressed me as I entered his cell is how tiny it was. The bed, table and kerosene lamp are still there, and the irises are still growing in the courtyard. When I thought of the masterpieces that were produced in that little room I no longer complained about some of my cramped quarters. The same caretaker was there, but at ninety-one his memories of Monsieur Vincent were a bit vague. If you are in France I highly recommend this area as a side trip. The Greco-Roman ruins of Glanum are nearby and as you walk in the countryside, you'll recognize the fields and farms that Van Gogh painted. Les Baux is only a few kilometers away with its fierce fortress town and the fabulous three star inn of Baumaniere, which is one of the finest restaurants in all of France.

While on the subject of painting interiors, I want to bring your attention to Edward Hopper and Richard Diebenkorn. Both artists break up interior space quite differently, but both capture the magnitude of light in an empty room in an overwhelming manner.

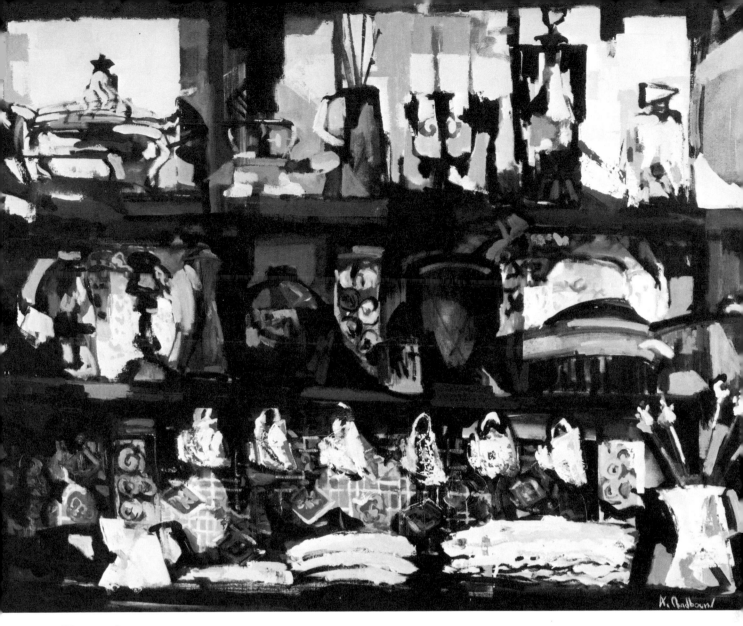

KITCHEN LARDER
30 x 40 inches — Oil on Canvas
Private Collection, Monaco.
Exhibited in the Pennsylvania Academy of Fine Arts, 1965.

While painting interiors I often move my portable easel into the kitchen. In this case the kitchen shelves with some of the objects I use daily were of interest to me, particularly the play of light as it struck the various shapes during different hours of the day. No specific light source was used, as I found the jumbled pattern of arbitrary lights and darks more interesting, creating a semi-abstract quality.

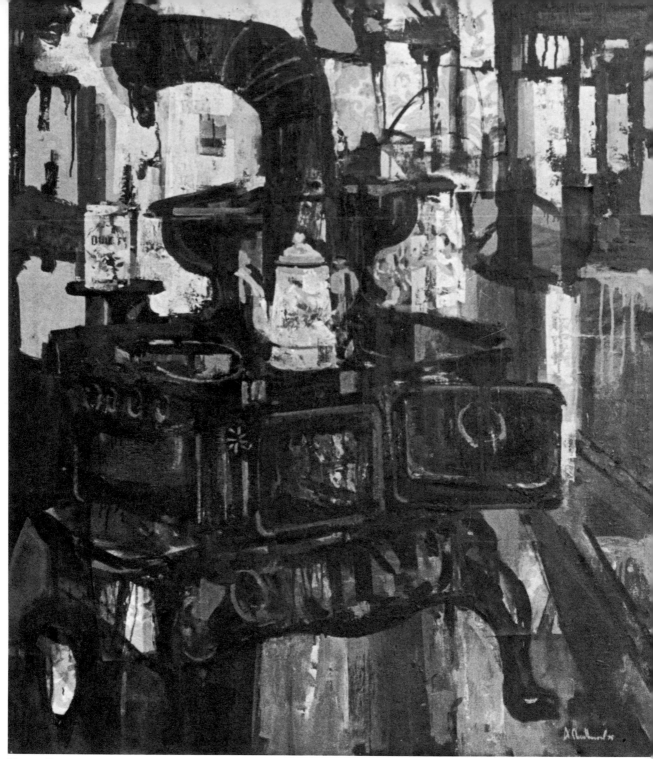

MAINE STOVE
40 x 50 inches—Oil and collage on canvas
Courtesy Barridoff Gallery, Portland, Maine.

I've always been fascinated with old cast iron stoves. I saw this old-timer about thirty years ago while visiting a friend in Maine, and I've been drawing and painting them ever since. Now with the energy shortage, you see all types, sizes and shapes of stoves throughout the country.

In this painting, a lot of collage was used to incorporate some of the wallpaper into the design of the picture. When the paper was first attached to the canvas with Elmer's glue, it jumped out from the rest of the painting in a disturbing way. To overcome this I painted over parts of the paper to keep it in key with the other elements. Many liberties were taken in foreshortening the floor plan, as well as distorting the stove as though it were seen from various eye levels. The kitchen was in an old farmhouse and had a rather beat up, dilapidated atmosphere. I'm sure Betty Crocker would not give it her seal of approval, although some of the best baked beans I ever tasted were cooked on this stove.

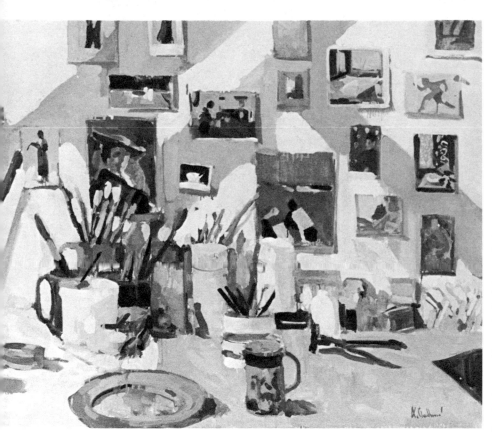

STUDIO WALL AND TABLE
50 x 40 inches — Oil on Canvas
Courtesy Barridoff Gallery, Portland, Maine

Everytime I look at a photograph of a painter in his studio I always peer closely to see if any reproductions are tacked on the background wall. We all share an affinity with other artists, and when we discover one of our own favorites gracing another's wall it makes us feel closer and more sympathetic to the artist. It does not surprise me to find a reproduction of a Velazquez behind a photo of Picasso or a Chardin behind Braque, but I was amazed when I saw a Picasso in Norman Rockwell's studio. Rockwell, I've learned, had a high regard for Picasso.

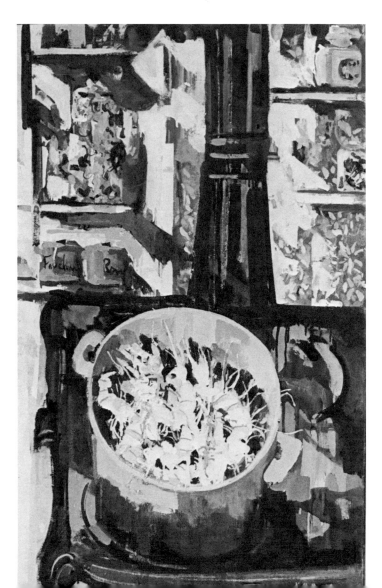

SHRIMP ON STOVE
40 x 28 inches — Oil on Canvas
Courtesy Barridoff Gallery, Portland, Maine

Here's another stove that was in a cabin we rented when we first moved to Maine. I made some drawings of the kitchen shelves and wallpaper separately from the stove, then put them together in this painting with a large pot of fresh shrimp. It's hard to find shrimp with the heads still on in this country, but they're much more fun to draw when left whole. The shiny black protruding eyes and long feelers add more variety of line. Again the stove was distorted to obtain the effect of looking into the pot while the shelves in back are seen from a different angle. The idea of breaking objects up into shapes and planes started for me as a student in Paris when I was influenced by Braque and Cubism.

It is rare for an artist to get a commercial assignment without the supervision of an art director. Some years ago this type of "dream" assignment was proposed to me by James C. Bowling, vice president of Philip Morris, Inc., a close friend of mine and collector of a number of my paintings. The project was to do a series of portraits and paintings of leading television personalities to promote identification between Philip Morris and the television shows it was then sponsoring. After a national tour to C.B.S. affiliated stations, the paintings would be given to the stars as a part of the company's continued interest in the arts and their close relationships with the television celebrities.

Even though I knew it would be lucrative, I had reservations about the project. There were so many highly capable illustrators who could do the job with more facility than I. After being reassured no art directors were involved and that I had the complete freedom to paint the subjects as I pleased, I accepted the challenge. Within weeks I was on my way to Hollywood, preceded by a full-scale public relations campaign. The project consisted of painting Jackie Gleason, Red Skelton, Raymond Burr,

SKETCH OF JACKIE GLEASON as The Bartender during rehearsals in Miami, Florida.

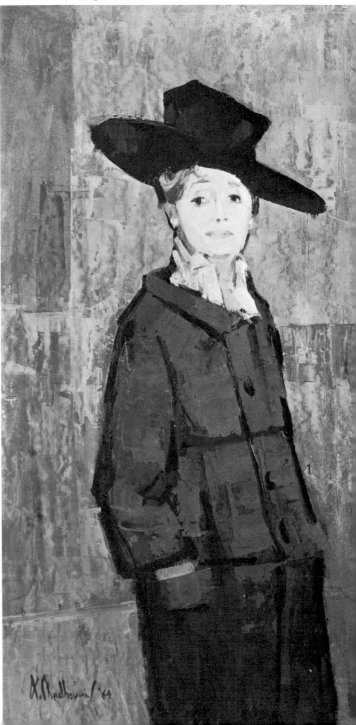

PORTRAIT OF HEDDA HOPPER
30 x 18 inches — Oil on Canvas
Private Collection, Beverly Hills, Calif.

E UMPS.
x 28 inches — Oil on Canvas
ection President American League Baseball Assoc.

The men in black, the umpires, are in complete
ntrast to all the color on the field and the players.
re two umpires with their padding suggested an
eresting silhouette of black shapes against the sta-
m and dugout.

Bob Denver of *Gilligan's Island*, Walter Cronkite, Al Hirt of *Fanfare*, The Baseball Game of the Week, Football Game of the Week and the late Hedda Hopper because of her help in setting up dinner parties for the stars to meet the artist. Being chauffeured to the studio sets in limousines and being entertained on a lavish scale at the Beverly Hills Hotel didn't stop me from worrying about the work that lay ahead.

I did the paintings, as I do most of my work, from a series of photographs and lots of rough sketches done on the spot. While I was working, I had to remind myself not to "tighten up," and as far as possible to be myself.

For some reason there is always a tendency for artists to change their way of working as soon as money becomes an important factor in the work. My best advice is to forget any preconceived idea of what you may think the client wanted in terms of other illustrators. After all, if Philip Morris had wanted Norman Rockwell they would have gone to him instead. Once I started splashing around in my own studio and getting involved with some of the ideas I had for this series, other thoughts fell into place and after nine months I had the work completed. During that period I would ask Mr. Bowling over to let him see how the work was progressing and, outside of the normal criticisms of the nose is too big, the mouth doesn't look right, I had complete freedom from the beginning. Once the paintings were framed and crated, I took my family along to some of the gala openings in Miami, Chicago and Beverly Hills. Like the song in *Wine & Roses*, "It Was a Very Good Year."

Not all clients and corporations will be as understanding and sympathetic as Mr. Bowling of Philip Morris, but there are hundreds of banks, television networks, publishing houses, and various other large companies that are buying art in a big way. This is a phenomenon that has taken place in America for the past fifteen or twenty years, and I hope the trend continues. As I said frequently on some of the T.V. talk shows that interviewed me at the time, "During the Renaissance, painters like Michelangelo and Raphael had the Church as their patron—I had Philip Morris."

THE GLADIATORS ►
60 x 30 inches—Oil on canvas
Collection Mr. Pete Rozelle-Chairman, National Football League, New York City

After watching several scrimmages, workouts and actual games from the players' bench during the heyday of the New York Giants, I became involved in a complicated series of sketches trying to describe the brutal power of professional football. Most of my efforts ended up being a mass of tangled, confused figures and numbers which was over-ambitious and meaningless in its fragmented design. I finally decided that the force of the game could be depicted more quietly by concentrating on the awesome size of the players standing on the side lines, focusing on the heavily taped wrists and hands that are used like clubs. The title "Gladiators" seems to say it all.

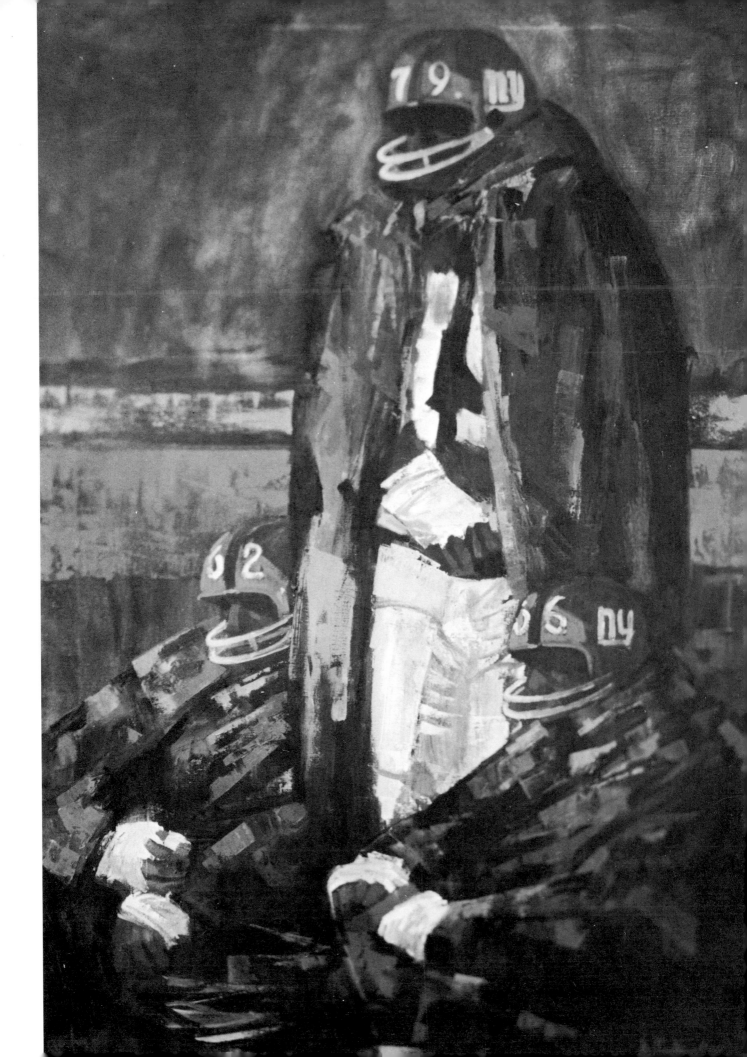

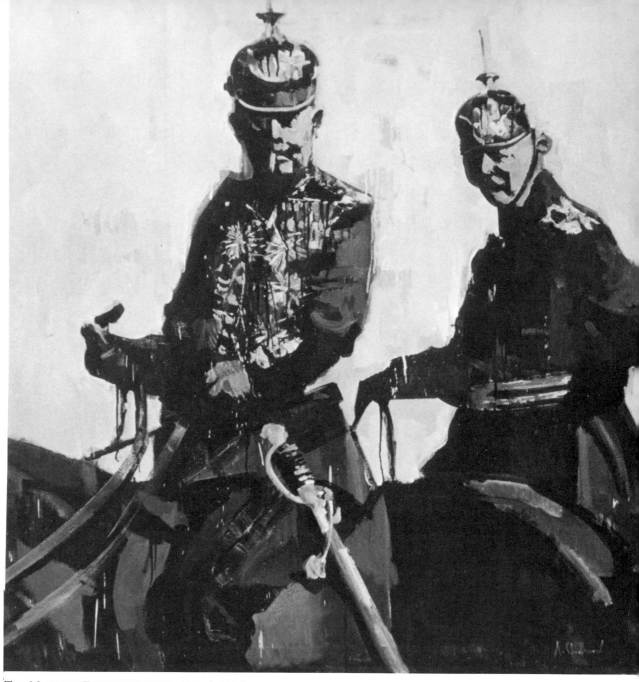

THE MILITARY ESTABLISHMENT—CIRCA 1914
50 x 40 inches — Oil on Canvas
Collection Mr. Icky Weber, Portland, Maine

Even though I grew up in the Depression, the "social realist" school of painting which was primarily funded by the W.P.A. never really moved me. Although some of the competent artists were nurtured by this movement, much of this "message" painting is similar to the official Soviet propaganda art. It often looks like second-class illustration and wears very thin with time. To me the grandaddy of all protest art was Goya, particularly his series of "disasters of war." Then come Daumier, the Mexican muralists—Rivera, Orozco and Sequeros—and finally Picasso with his painting, Guernica.

Every time I tried my hand at portraying some of the ills and injustices of the world I fell flat on my

face. I had an instructor who used to say "P something you love very much or something you I —but don't try to be neutral about it." The pain above is about as close as I come to doing anyth with a message in it.

The idea for this picture started during the ties when many of us were protesting the war in V nam and war in general. Ever since childhood, photographs of Prussian generals during World W represented something frightening and evil to me I decided to pick the Kaiser and his chief of s General von Moltke as my image of a war machin military establishment. The spiked helmets, monocle, medals, saber and the withered, glo hand of the Kaiser all attempt to capture this eff

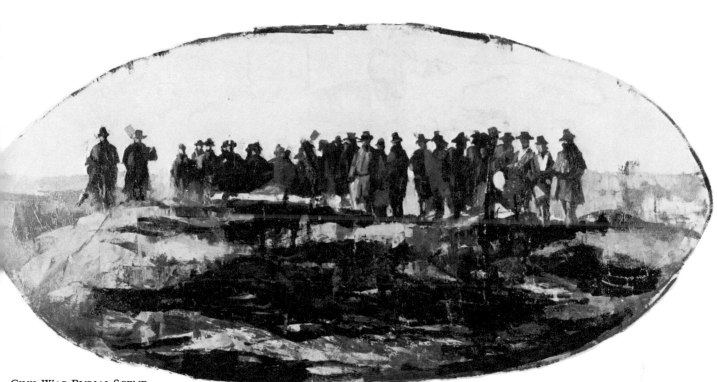

CIVIL WAR BURIAL SCENE
20 x 40 inches — Oil on Canvas
Collection Mr. & Mrs. William Adkins, Easton, Maryland

I am not a Civil War buff, nor am I a great student of that tragic period in our history. I was first drawn to this subject when someone showed me a book of Mathew Brady's photographs. The quality of the prints made more of an impression on me than some of the terrifying descriptions of slaughter on the battlefield. Because of the grainy surface and sometimes blurred images, the photos had a quality I felt would lend itself to paintings. What I attempted to do here was to capture the essence of the period rather than slavishly copy the photographs. I decided to work in an oval shape to emphasize a daguerreotype effect and help establish the feeling of a period piece. In this burial scene I kept the figures and the shapes in sharp contrast to the off-white sky. The foreground was all scumbling and dripping, using abstract shapes to help strengthen the design. Simple as it is, it took two months of off and on painting to finish it.

THE GENTLEMEN IN BLUE
30 x 60 inches — Oil on Canvas
Courtesy Barridoff Gallery, Portland, Maine.

These generals and officers were picked at random from the Brady photographs more for their humorous, statuesque poses than any military accuracy. Some exaggerations were made here and there to bring out the pattern of the white gloves and sabers.

CHAPTER FIVE
PAINTING TECHNIQUES

TEXTURE

ALTHOUGH TEXTURES IN paintings are sometimes used to better describe certain objects, I think it is more important to think of textures in terms of enriching the surface of a painting. Indeed, there are hundreds of ways to use a painting knife to imitate a blade of grass or the weathered boards of an old barn, but it remains just that. An imitation of nature. There is nothing particularly wrong with such an approach to painting, but in terms of structure and content it is somewhat meaningless. If, on the other hand, we think of textures as a means of enriching the total painting it can become more meaningful as we respond to the tactile surface. This is a rather thin line of argument but when we look at the powerfully painted globs of paint on Rembrandt's ''Man With a Golden Helmet'' we are drawn to the magnificent light textures of the helmet first then to the softer subdued features of the head underneath. First it is a textured shape; second, it is a golden helmet—and what a helmet!

When thinking of textures, we usually think of thick paint; but thin paint can have textural variety. Sometimes the actual grain of the canvas makes a beautiful texture in relief to the thicker paint next to it. Degas and Manet used this technique frequently in their portraits, so we see the texture of the canvas in the soft, mysterious shadows. Your approach should be personal and you should judge for yourself as you paint and discover the style you like best. A painting that is done completely with thick paint can become as tedious as one that is done with a sameness and monotony of brush strokes.

On page 73, I have chosen a painting of ''Mussels on a Stove'', not because it is a great painting, but because it incorporates many of the textures I use. I thought it could be useful in showing you various ways textures can be applied.

On the left side of the light tones behind the tray are a series of strokes done with a roller or brayer. These textures applied over a thin area can give a toothy, grainy quality similar to the textures of a wall painted with a roller. Sometimes artists will add sand to their paint mixture as did Braque in his early cubistic paintings. It is interesting to remember that Braque first started his career as a ''peintre des

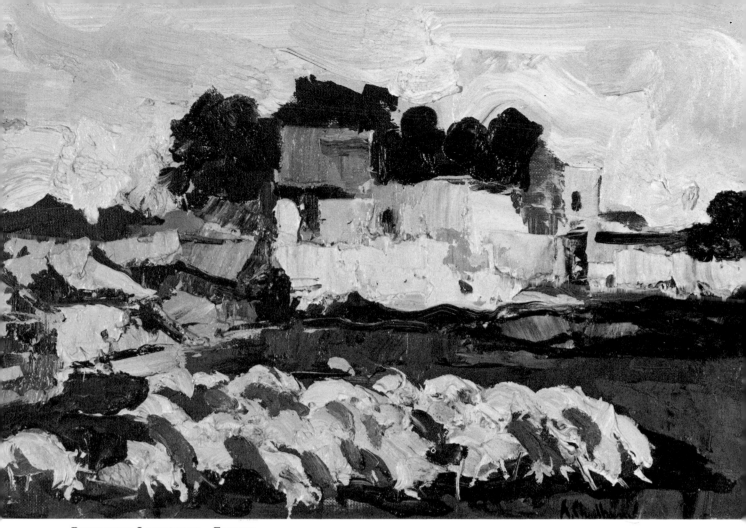

PROVENCAL LANDSCAPE—FRANCE
12 x 16 inches—Oil on canvas
Collection Mr. & Mrs. James C. Bowling, Darien, Connecticut

In 1971 I returned to France after an absence of twenty years and my first impression was the opulence and abundance of goods in the shops and the well-dressed, well-fed people. I was visiting my brother who was our Consul General in Marseilles at the time, and spent most of my time in the Provence which I had never seen before. It was in Autumn during the vendange or wine harvesting season, and the countryside seemed to reek with richness and abund-

ance. Perhaps this is what led me to use such thick paint; I felt as though the landscape had been fashioned by a pastry chef. In piling on the rich textures I wanted to get the effect you could almost eat the pigment. Such an emotional feeling required a broad approach, and in the process a lot of detail of identifiable objects got lost along the way. An example is the treatment of the flock of sheep grazing in the foreground.

batiments,'' or wall painter putting up posters. It was this influence that first started him on the use of collage in painting.

At the upper right of the picture you will see some doilies. This was accomplished by painting over the little holes giving the impression of busy wallpaper. Other stencils can also be used effectively. Don't overuse this technique as it will become too prominent and create a "tricky" look.

On the lower left are some broad scumbling strokes done with the broad side of the painting knife. All sorts of rich textures can be obtained with this useful tool. Again, discretion is in order or the textures will become overpowering.

71

Some of the paint in the background area was stippled on with a short, stubby brush over a doily to achieve the busy patterns of wallpaper design. When I pulled off the doily, the paint showing through the little holes looked too obvious and jumped out; therefore, I scumbled around with a brush to blend things together a bit. Over this I added some splatter by letting the paint run freely with plenty of medium. Sometimes you can have better control in splattering or dripping by placing the painting on the floor. Be sure to cover the areas with paper that you don't want covered with drops of paint.

On the mussels and pot I used a fairly loose brush technique. I usually start with my thin darks, then add the thicker pigment in the rich light areas. On the pot I allowed some of the paint to run to create some drip textures that most cooking pots seem to acquire.

Since the stove is basically black, I used some hard and soft edges all in fairly close values to add variety. In some of the thin areas you can see the texture of the canvas showing through. For soft edges, you can use your thumb or a rag to wipe the paint to make it blend. Artists have been doing this for centuries. In some of Rembrandt's paintings you can see his thumb prints in the deep shadow areas.

In painting, any technique is permissible so long as it doesn't look tricky and overpowering. I like to think of textures as enhancing the surface of a painting rather than merely describing an effect.

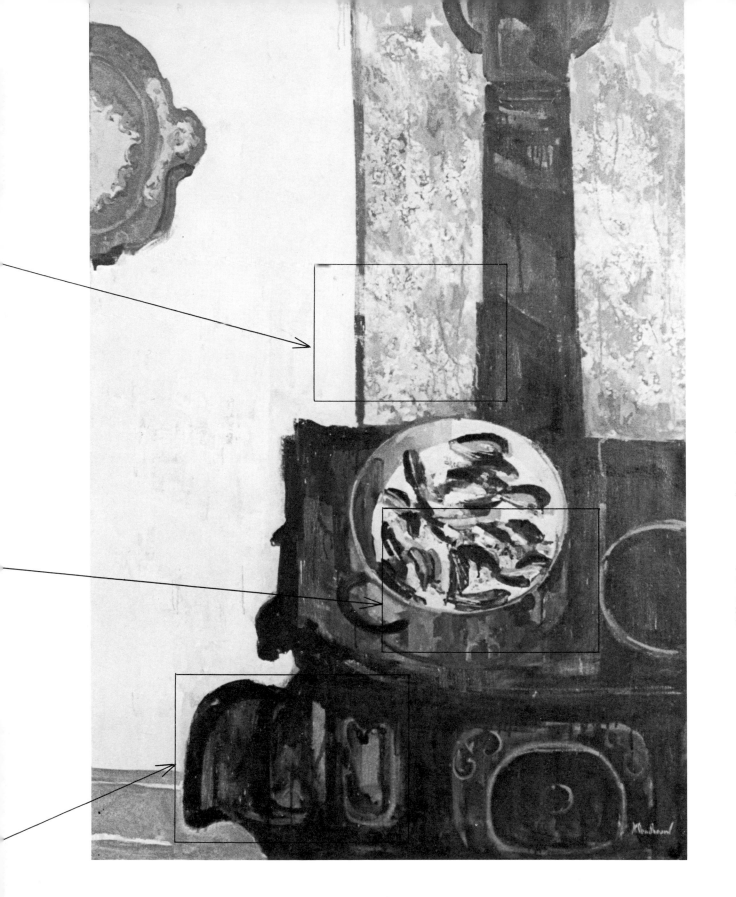

Here's another stove painting with a large copper pot of mussels in cream. Because mussels are so cheap and plentiful in Maine, I cook them frequently in various ways and often end up painting them. In order to concentrate on the gleaming pot against the dark stove, I tilted the perspective so one can look into the pot with the mussels. A lot of different techniques were used to build up the various textural surfaces shown on page 72.

RED SNAPPER ON BLUE PLATTER
36 x 36 inches—Oil and collage on canvas.
Courtesy Barridoff Galleries, Portland, Maine.

This close-up of the fish head shows how some of the thick and thin paint was built up in the painting.

The texture of the canvas shows through the thin, dark areas with the wallpaper pasted on top. While I painted I covered the edges of the paper so that the pattern of the design would become more prominant. I left the drips of wet paint as it helps to add another dimension on top of the collage.

Here and there cut out bits of paper were used to get a razor-like edge on the painting. This also helps to confuse the use of collage. Some palette knife strokes were added on top of the paper for other textures.

When I cook red snapper I generally like to bake it whole. With the head and tail left on it makes a festive looking dish with a lemon stuck in its mouth and a few sprigs of parsley on my grandmother's oval Victorian blue and white platter. Before the fish went in the oven I did some quick color notes on a small canvas trying to capture that iridescent quality of the shiny fish scales against the pattern of the blue platter. When you paint fresh fish you have to work fairly fast as the color of the skin changes rapidly. Sometimes I place the fish on a bed of ice cubes to hold the color longer, but generally I don't spend more than an hour at this type of color sketching.

When I started to arrange the elements on a larger canvas I used Elmer's glue to attach some wallpaper designs both on the background and on the platter. Next I covered the pieces of paper with a thin coat of Hyplar which protects the paper and makes it possible to paint over it with oils. In some areas I painted the pattern of the paper and platter so that it would give an almost trompe-l'oeil effect to the areas where collage was used. I became interested in this technique by studying the works of Antoni Cláve, a well-known Spanish painter I knew in Paris. So long as the technique does not get "tricky" looking, it can be fun to imitate the various patterns of the cloth or paper. The painting looks terribly busy to me now, although the results from the oven were spectacular.

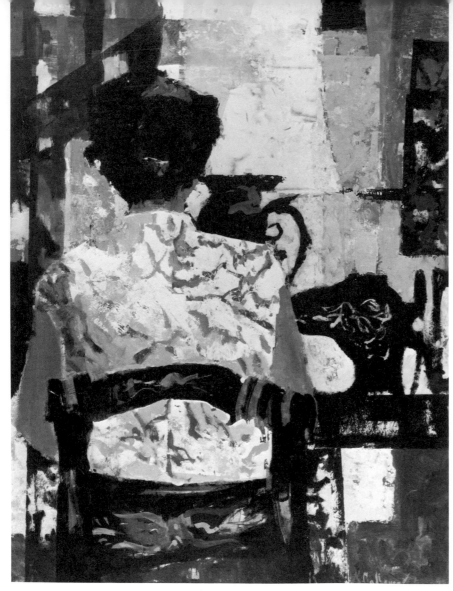

WOMAN AT SEWING MACHINE
30 x 24 inches — Oil on Canvas
Private Collection, Washington, D.C.

In the painting of "Woman at Sewing Machine" I used the decorative pattern of the blouse to make it a cohesive unit with the other Victorian shapes of the lamp, sewing machine, and Hitchcock chair. The textures are fairly evenly distributed to keep the design flat and two dimensional.

PATTERN

When we speak of pattern in painting we generally mean the light and dark relationships in a picture. It also refers to the repetition of elements or combinations of forms and shapes used in a painting. Usually the first thing you see in a picture is the value pattern. As you move closer you become aware of the color, texture, brushwork and so on. This is one of the reasons art schools stress the importance of values first.

In the paintings on pages 71 through 74 are some examples of my early and more recent work where essentially there is no attempt to describe light and shadow, only light and dark shapes. Some of my paintings may be more realistic in handling than others because the shapes themselves are easily identifiable, but in general my aim was to freely interpret the objects through decorative use of pattern.

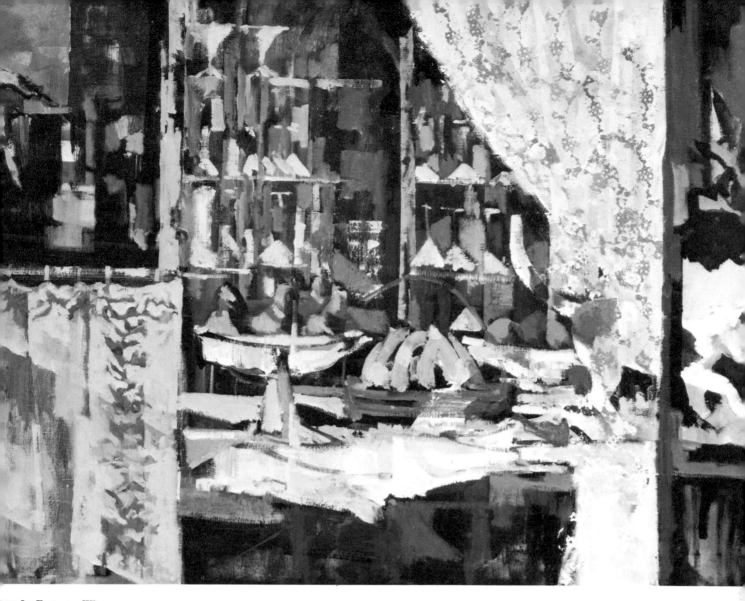

TS IN FRENCH WINDOW
x 38 inches — Oil on Canvas
ate Collection, Palm Beach, Florida

This painting was done from one of my old Paris sketch books of nearly thirty years ago. In those days I used to paint on the spot whenever possible, but painting on the sidewalk in front of the restaurant would cause a commotion, and a crowd, so I discarded the idea. Later I came across the sketch and decided to develop it into a painting. One of the reasons is I like seeing pets in restaurants, and Paris abounds in them.

The broken light reflected in the windows can be fascinating to paint as it keeps changing. This is another reason for painting in the controlled light of my studio. I started with the position of the cat on the left next to the potted plant. Then I concentrated on the shelves of glassware and compotes of fruit which were partly obscured, like the cat on the right by the lace curtain. Pulling all this stuff together took me ages, and I'm not so sure that it works. However, it gave me many pleasant memories thinking about those snoozing cats behind the warm sunlit windows.

LOBSTERS AND CLAMS
38 x 38 inches — Oil on Canvas
Courtesy The Monson Gallery, New Haven, Connecticut

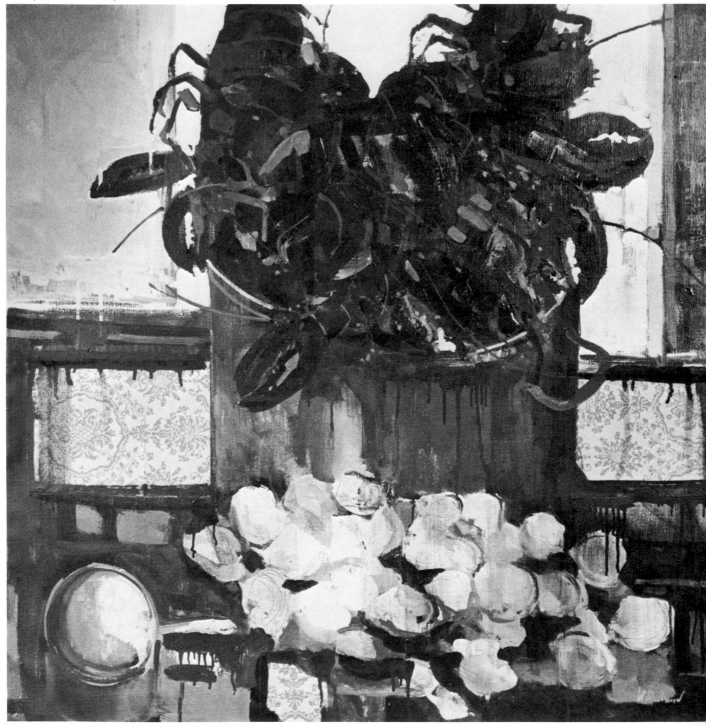

Anyone who has enjoyed a Maine clambake should be familiar with this subject. I filled the pot with the live lobsters before I cooked them which gave me a chance to draw them while they were in action, wriggling and thrashing about. I did about a dozen rough sketches before starting the painting a day or two after the feast. Like other familiar objects with definite shapes, it is fun to treat a lobster as a mass. Their identity becomes less obvious except for a few claws here and there in silhouette. The clams were also uncooked and merely strewn around the kitchen table at random. Since the whole painting was based on the dark silhouette shape of the lobsters, I added some red wallpaper collage to the background behind the pot. The painting was done with a fair amount of pigment and medium, and some drips took place while painting. I rubbed some out and left some as I liked the effect. Such things are a question of personal choice. Certainly dripping paint is not always a desirable effect.

78

CHAIRLIFT
14 x 24 inches — Oil on Canvas
Courtesy The Munson Gallery, New Haven, Connecticut

When my family goes skiing I am the one who stays home and cooks the soup to appease the hunger of the returning athletes. The scenery is grand but I have never taken to the sport. Once in a while I'm talked into going to the slopes and having a picnic at the lodge. This means I sit around and do sketches all day. Shown here is the result of on of those trips.

At first I had the suggestion of trees and moun-
tains, but as I kept working on the patterns of brightly colored ski outfits, I felt any background or distant elements unnecessary to the composition. What finally developed was a series of white and off-white rectangles which brought out the movement of the chairlift by reducing the sizes of the figures as they moved back into space. There is no attempt at modeling the figures or any use of light source as I wanted the pattern to be kept two dimensional.

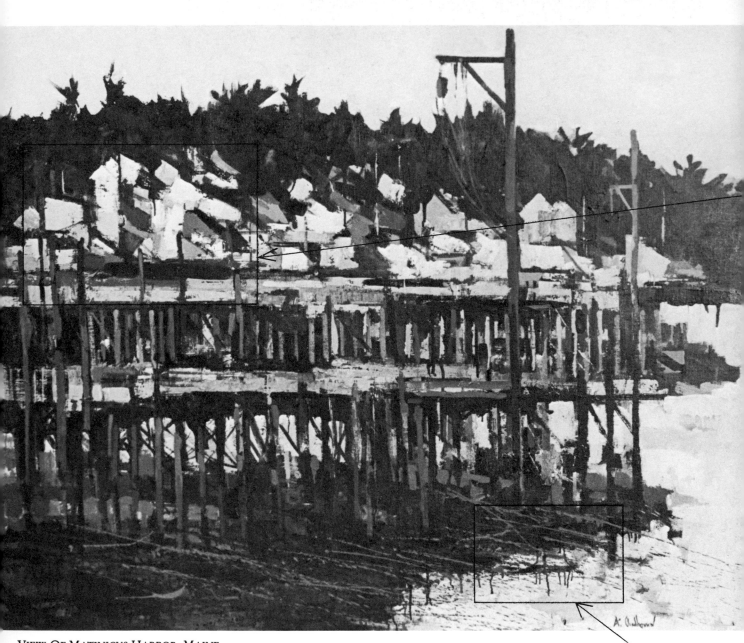

VIEW OF MATINICUS HARBOR, MAINE
40 x 50 inches — Oil on Canvas
Courtesy Barridoff Gallery, Portland, Maine
Exhibited Augusta State Capitol—Maine Painters 1975

Matinicus is an island off the coast of Maine which is about 23 miles from the mainland or as they say up here, ''Closest to Spain.'' It's one of the most unspoiled and primitive spots on our coast. Things haven't changed much since the days when George Bellows painted there in the late twenties, and it's just about as Down East as you can get.

This particular scene was done from watercolors and sketches I made on a trip with my friend and painter Charles Reid some years ago. Since there is no transportation on the island and our cabin was on the other side, I concentrated most of my sketching in and around the harbor as it had all the textures and patterns and smells that I was looking for. Wanting a rather free adaptation of the scene I used a broad approach in applying the paint which is demonstrated on page 75. The colors were kept somber and low in key except for the angular patterns of the lighthouses and some of the warm grays in the pilings.

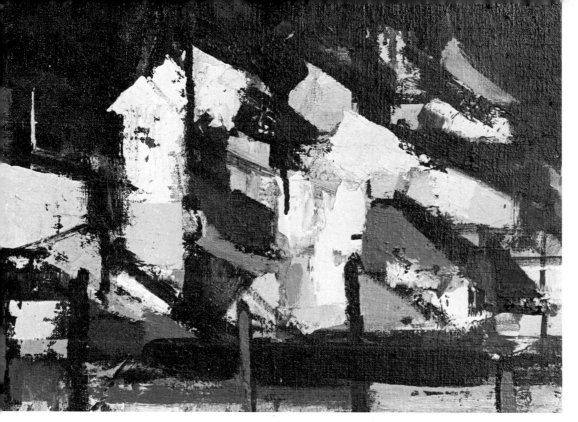

In this closer view of the buildings, you can see some of the thick pigment has been built up the thinner darks. I like to keep changing areas ping them out and repainting or painting over This requires keeping the painting wet and If you wanted to paint the scene with accuracy

and detail, this method of working would not be suitable. There are probably dozens of little window panes I left out and hundreds of clapboards and other small details which are missing, but as I stood back from the easel I didn't feel they would have helped or enhanced the overall impression I was after.

In the deep, shadow areas of the piers, the water full of seaweed, rocks and mud which reveal elves at low tide. I was only interested in using es which I hoped would enrich this area, so I he painting on the floor and used a house r's brush to fling on the paint. If this technique d too obvious, or if the values and color were

not right, I put the painting back on the easel and scraped the area out with a palette knife and started over again. For me one of the beauties of oil paint, is the constant give and take of trial and error, being able to wipe out large areas and reestablishing others. The push and pull Hans Hoffman taught his students, can only be done if you're willing to take a few chances. I firmly believe it's worth the gamble.

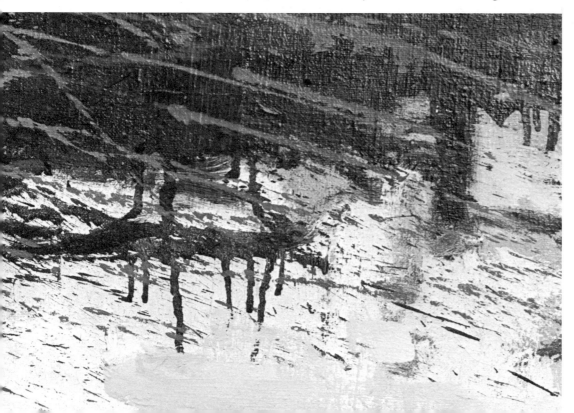

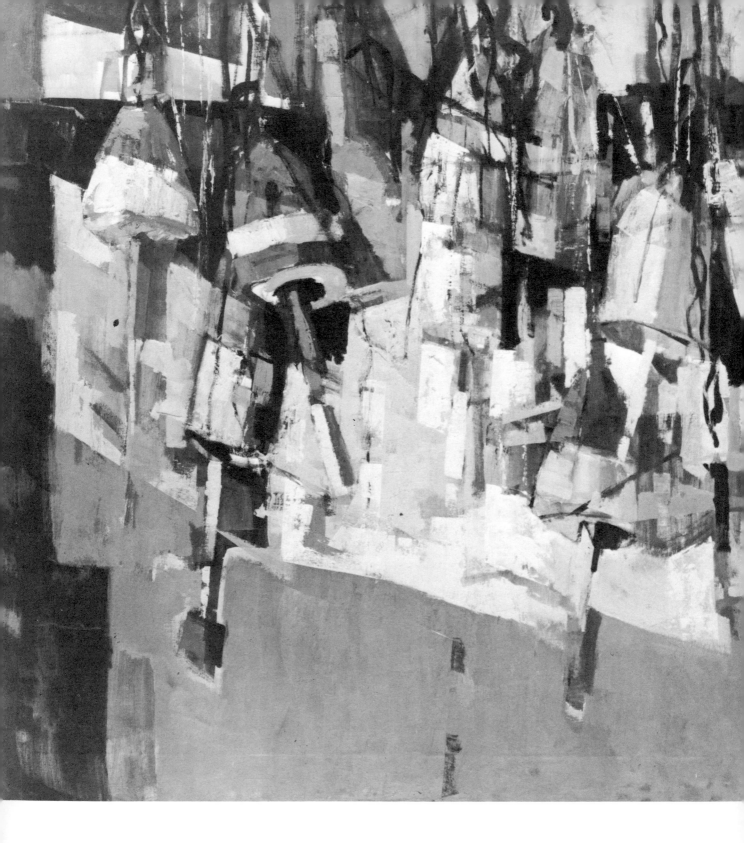

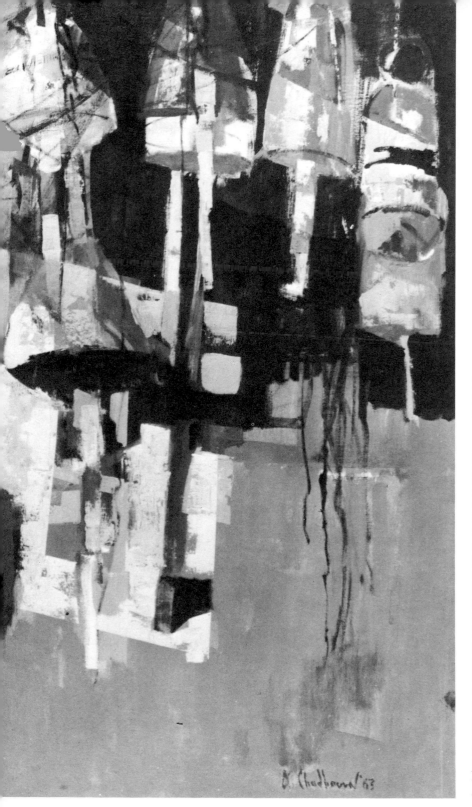

LOBSTER BUOYS
30 x 60 inches — Oil on Canvas
Collection Mr. & Mrs. Alfred Avison, Darien, Connecticut

During my trips to the islands and fishing ports of Maine I've been able to collect a large number of lobster buoys given to me by lobstermen I've known over the years. I keep them around my barn studio and sometimes string them up on some beams as they make marvelous objects to paint. Too often they are used as props in paintings to give the so-called Down East flavor to a scene. Like most objects that become overfamiliar, they only add up to a sentimental adornment to a picture. In this arrangement I wanted to paint them for what they were: large, chunky shapes of varied color, pattern and textures. A shaft of light came across them while I painted, which further enhanced the broken patterns of light and dark on the buoys themselves. Strong cast shadows were used here and there to give relief to the flat background. In other areas lighter buoys were painted against dark areas as in the upper right-hand corner. With all of this jumble, I hoped for a rhythmic movement of line and shape which would tie in with an overall pattern of varied shapes and color.

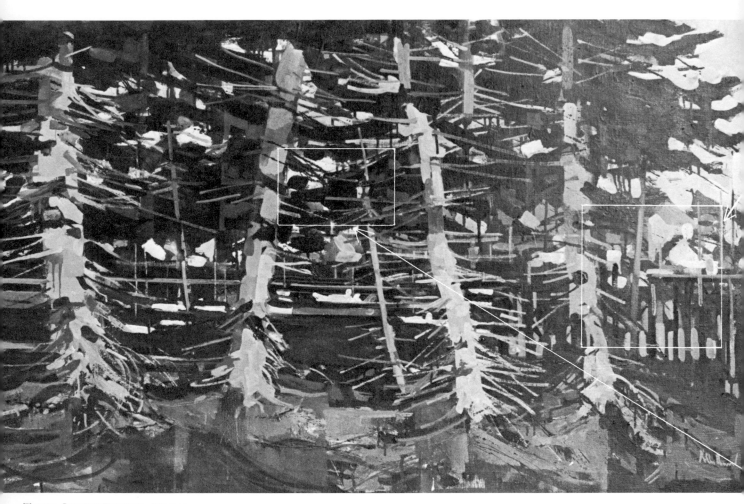

TREES, SOUTH BRISTOL, MAINE
30 x 60 inches — Oil on Canvas
Courtesy Barridoff Gallery, Portland, Maine.

This view of South Bristol, Maine, is seen through a large mass of pine trees. When I get "hooked" on a place like this, I return to it several times to get different impressions and vibrations. What I find most challenging is to see how many ways the same scene might be interpreted. By taking walks with a sketch pad and jotting down mental and visual notes on my way, I usually come home with a fair variety of paintable subjects. What attracted me to this scene were the glimmering whites of a few simple houses and fishing boats seen through a tangled mass of evergreens. The trees were a lovely mauve color with the sun making colored shafts light on the brittle twigs. The deep greens of upper foliage were enhanced by small spots of showing through. Because we get so much snow here, the lower branches are bent downwards, and the middle section they appear to grow straight from the trunk. Only at the top do the limbs cli upward.

To help understand the paint handling he some larger swatches of the actual brush work shown. Many students have problems painting d foliage against a light sky. The same problem ar with any other kind of tree or foliage.

84

On the extreme right you will note that I've painted some of the light sky over the shapes of the buildings and foliage. I was also covering up some of the splattering effect that didn't work. I went back into the darks of the pier establishing some darker values under the pilings and added some other diagonal shapes to this area. None of this is really difficult in terms of paint handling, as long as you're willing to put up with a lot of wet paint rags, worn out brushes and the use of an abundant amount of pigment.

This is a close-up of an area almost in the direct center of the canvas. I purposely didn't focus on the shapes of boats as I wanted to concentrate on the paint handling. Some of the darks are painted over in thick, linear strokes which is fairly easy so long as the darks are kept reasonably thin. If this doesn't work, just pile on more paint in the lights and force it. In something as complicated as dark foliage against the light accents of the sky, it's impossible to plan exactly where all the contrast is going to take place. If I had a careful plan in mind, then it would be simpler to let the darks dry for a day and go back and paint the lights on top. But it doesn't work that way for me because I like to see change take place at the moment I'm painting. I believe some kind of intuition moves your hand to make these changes while the painting is in progress.

CHAPTER SIX
FIGURES AT THE BEACH

IF YOU CAN draw a barn, a tree, a fishing boat or a vase of flowers, there is no reason why you can't draw a figure. Generally when we think of figures in paintings there is some preconceived notion, some kind of Renaissance conditioning that shapes our minds into thinking that figures have to be difficult to draw. Indeed, if we are discussing drawing in terms of the Florentine Masters then, forget it. On those terms it's a very hard, terribly long and difficult discipline to achieve. One of the best draftsmen I ever had as an instructor, Rico LeBrun, was fond of saying, ''If you're going to have a footrace with the Old Masters, guess who's going to win.'' This statement, although discouraging at the time, was his way of opening our eyes to a more creative and more personal way of seeing the figure. It made it easier for us to understand some of the extraordinary revolutions in drawing that took place from the early Renaissance to the drawings of Matisse and Picasso. Without going through the years of struggle, I encourage you to think about adding figures to your paintings just the way you would add some apples to a still life. It's a matter of simplifying your thinking and doing a little exploring without the fear and hesitation.

Recently my landscape class was faced with an incredibly complicated scene at a nearby boat yard. All sorts of busy stuff was there to paint: boats in the water, boats in dry dock, huge cranes and pulleys, sails and masts of all sizes and shapes, boat-cradles, piers and pilings with houses and boat sheds made a scene of complex confusion. It was a question of sorting it all out and simplifying everything that was in front of us. Had the class been held at the beach at Coney Island, my remarks would probably have been the same—simplify and look for shapes and values. That's why I think it's reasonable to assume that if you can paint some flowers in a vase, you are capable of handling figures in your paintings.

If you are interested in pursuing the further study of the figure, there are a lot of good books on the subject, but be sure to get one that suits your capabilities. Many of my students have formed their own sketch classes by chipping in and hiring

Continued on page 88

86

COMPO BEACH—WESTPORT, CONNECTICUT
30 x 40 inches — Oil on Canvas
Courtesy Barridoff Gallery, Portland, Maine.

When I was living in Westport, Connecticut, it was traditional to have a Fourth of July picnic at the beach. These occasions were never a good beach day for sunbathing or swimming because of the crowds, but they were pleasant in other ways, and it always made a good excuse to do sketches of figures in normal but odd and funny positions. When I went over these sketches days later, I spread them out on the floor and picked figures at random to obtain a patchwork of shapes to serve as the basis for my busy design. Although some of the figures indicate form, light and shade, the emphasis I wanted was of a flat pattern of bright colors against a high-keyed background. As I look at this reproduction now I feel I may have overdone the use of sharp, crisp edges in my efforts to build up the pattern. This sort of thing should not appear forced, but should be a natural response to a way of interpreting nature.

In paintings like this there is little attention given to the anatomical accuracy of the figures. Also, the scale of the figures is sometimes out of whack. Usually this is not important. The large, rather rotund lady standing on the right, for instance, is much too large for the prone position of the figures on the left. I must have some attachment to this large lady as she reappears in a number of my beach scenes.

87

their own models. Also there are many continuing education art courses given throughout the country worth looking into. There is no substitute for drawing from a live model, and most courses given by continuing education classes are reasonable.

FIGURES AT THE BEACH—SKETCHES

These sketches were done at various beaches and will give you some idea of the casual character of most of my drawings. Naturally, the more you sketch and become familiar with the figure, the more confidence you will gain with each drawing. The reason I picked these sketches is to show you how completely free you can become in your interpretation without being a whiz of a draftsman. Most of these drawings were done on a small 6 x 9 inch sketch pad. Depending on how you sit in your beach chair, there is no need to worry about people peering over your shoulder while you do these rapid sketches. Quite obviously some of my models would be aghast if they saw what happened as they were translated to my sketch pad.

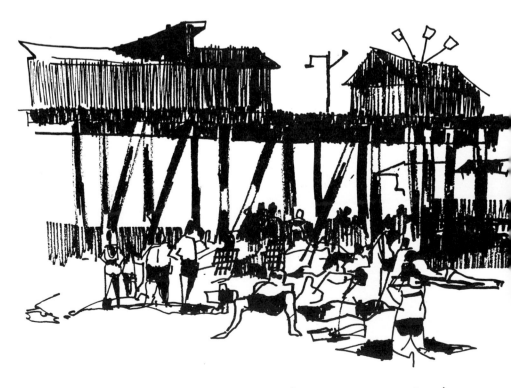

OLD ORCHARD BEACH . MAINE 15 AUG. '77

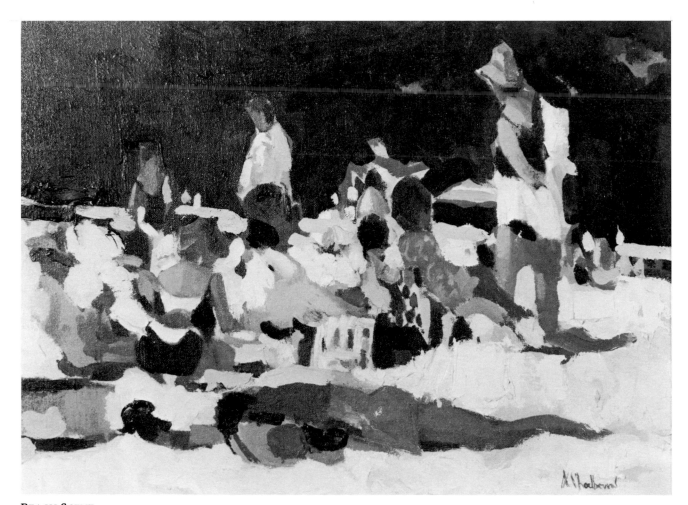

BEACH SCENE
12 x 20 inches — Oil on Canvas
Collection of Mr. & Mrs. David Charleson, Rowayton, Connecticut

Here's a case where a dark blue, almost black, ocean was used which had nothing to do with the scene that inspired the painting. Had I painted on the spot, this would not have happened, since I'm usually too influenced by what's in front of me. Also the light and shade patterns are completely arbitrary. The long dark figure in the foreground was shaded by an umbrella in the original sketch, but since the umbrella would have robbed the standing figure on the right of her importance, I decided to leave it out. Judgments of this sort are much easier to make in the studio away from the scene because your attention is riveted to the problems of the painting. As a general rule, figures on the beach appear darker than the sand regardless of the bright sunlight. In some areas the light values get very close where the sunstruck objects like white towels or light flesh tones get lost against the light sand. Other areas of deep shadows and bright colored bathing suits makes an ideal situation for forcing color to its fullest intensity. A lighter more realistic treatment of the water did not give me the impact I wanted in order to carry the strong diagonal running through the composition. These decisions are purely personal, but I think it's important to understand the basic concept. Detail or realistic light conditions don't necessarily make a picture look better.

89

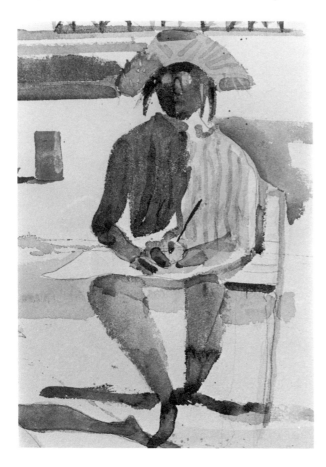

FIGURES AT THE BEACH—Watercolor Sketches

Because I like the spontaneous and immediate results of watercolor, I often carry my small Winsor & Newton box to the beach with me and use it for painting figures like the ones shown here. These were done on a small 3 x 6 inch pad of cheap watercolor paper. There is no attempt to show you how to do flashy figures as I try to keep my technique as simple as possible by just putting down the colors as I saw them. There is nothing subtle about the various watercolor techniques. Splashing around with rough drawings like this can be rewarding and fun to do. The simplest of line drawing was usually done first, then some of the light washes were added on top. Very little "wet-in-wet" technique was used because the paper was almost always dry due to the heat. The darks were added on top where I felt they were needed.

90

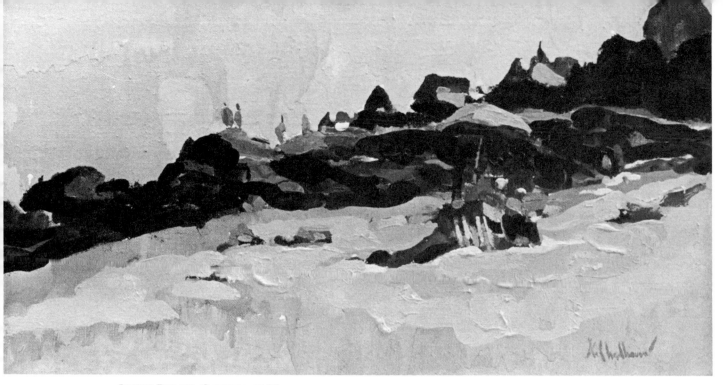

LITTLE BEACH, OGUNQUIT, MAINE
12 x 18 inches — Oil on Canvas
Collection Mr. & Mrs. Robert R. Masterton, Cape Elizabeth, Maine.

There is something comfortable and pleasing about uncrowded family beaches that stir up nostalgic memories of summers spent on some of the sandy, rock-lined coves around Laguna Beach, California, when I was growing up. A bunch of kids standing on the rocks look pretty much the same anywhere. However, the dormer windows and chimneys give the houses a definite New England shape as they loom over the bluffs. It has always amused or confused my sense of social orientation that some of these enormous dwellings are still called "cottages."

Although both of these paintings are somewhat similar, they are different in mood and color. In this scene all the darks were reasonably subdued except for the pink tones of the sand, the one or two spots of bright color on the umbrella and the clumps of figures. The late afternoon light was done mostly in violet grays and warm pinks.

LITTLE BEACH, OGUNQUIT, MAINE
24 x 40 inches — Oil on Canvas

Moving in closer to the scene and using sharper contrasts of lights and darks, this picture has brighter color as I was trying for a completely different mood. Due to the intensity of light I was after, the paint handling is more brittle. The edges are sharper and the pattern is more obvious with most of the lights against strong darks. Some of the characters in this painting were used in previous paintings and sketches.

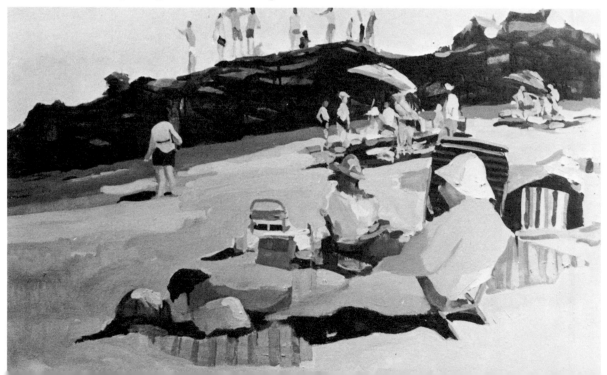

CHAPTER SEVEN
PAINTING COASTAL VILLAGES AND HARBORS

OF ALL THE subject matter there is to paint, nothing is more universally popular than harbor scenes. Whether it be a Down East village in Maine with rugged work boats or fancy places like Newport, Rhode Island or the Bay of Monaco with all their gleaming yachts, the allure of such places must touch off some envious, romantic notion in all of us. Maybe that's one of the reasons I find this subject difficult to paint without getting sentimental about it. There seems to be a paradoxical situation here. I know some good artists, some close friends, who would not go near or attempt to paint anything that closely resembled a fishing harbor for fear of being "corny." I don't believe it is the fault of the subject matter, but rather the overwhelming abundance of bad painting that has been associated with it. A lot of harbor scenes were done by Braque, Picasso and Matisse, to mention a few, and they are not considered corny.

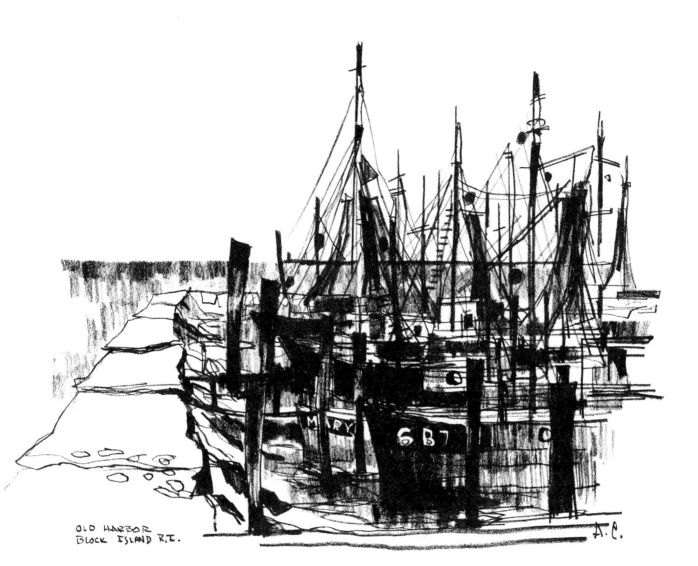

OLD HARBOR
BLOCK ISLAND R.I.

VIEW OF OLD HARBOR
Block Island, Rhode Island
Charcoal pencil on Strathmore paper

This drawing, like many of my sketches, led to a larger somewhat semi-abstract painting of this subject weeks later. Instead of trying to sort out each boat and mast, I tried to visualize the overall mass of boats, masts and rigging and fit it into a vignette shape. Working as a flat pattern with only the breakwater as a foil, I looked for the design of the linear structure against the flat hulls of the boats.

93

VIEW OF NEW HARBOR, MAINE
30 x 40 inches — Oil on Canvas
Courtesy Barridoff Gallery, Portland, Maine.

This is another favorite harbor of mi which is off the beaten track. You can spe hours here crawling in and out of pilings a piers sketching without being bothered. T fishermen are too busy working on th boats or gear to be bothered with itiner: sketchers.

Although the painting is fairly direc spent hours moving boats around unt found the effect I desired. This happens me when I use too many sketches and many points of view. When I decided simplify the whole foreground water ar the shapes of the boats and buildings beg to settle down, and I could concentrate m thoroughly on the small patterns of hou and buildings in the distance. To so people, repainting and going over surfa constantly does not sound like fun, but the only way to solve picture problen Things seldom come out right for me first time around.

VIEW OF SOUTH BRISTOL, MAINE
10 x 14 inches — Oil on Canvas

Here is another view of South Bristol, a small fishing village I've mentioned earlier where I've done dozens of paintings. In paintings such as this, I find by limiting myself to large brushes on a small surface, I avoid getting too involved with details. As I kept building up the rich paint in the light areas, the shadows in turn were made darker and darker. I began to think of these areas as shapes rather than cast shadows. The top of the picture was kept fairly flat with just a band of light crossing the roof and the irregular shapes of the trees. The telephone poles were exaggerated as I felt a need for the strong verticals against the horizontal direction of the darks. In the original sketch, the road winds through the picture to the distant hills. In the painting I slowed down this strong movement by breaking it up with the horizontal darks.

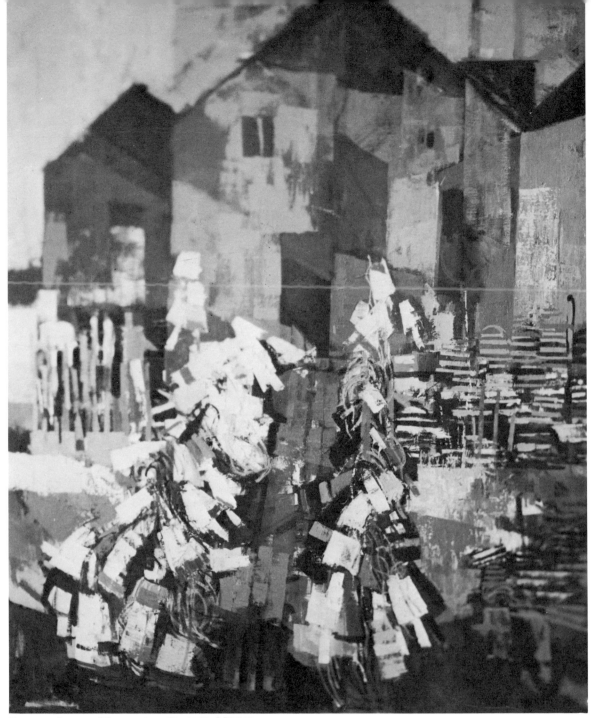

FISHING SHACK, MONHEGAN ISLAND, MAINE
Oil on Canvas
Collection Mr. & Mrs. Alfred Avison, Darien, Connecticut

When I first visited the island of Monhegan off the coast of Maine, I took advantage of the clear weather and sketched continuously in my enthusiasm for the place. Many weeks later I began to recognize all my subject matter, and scenes that I thought were original had been done hundreds of times before by other artists. I knew that a lot of artists had lived there and the place was still popular with artists and tourists, but I had never been that familiar with the subject. It surprised me to see all the reproductions and photographs of the same scenes I had drawn. This didn't spoil my fondness for the place, and if I were to try another view of this shack, I'm not sure I wouldn't settle for the straight on view I first picked.

CHAPTER EIGHT
ADVANCED TECHNIQUES

IN 1952 I returned to the United States after being away for over five years. It was a depressing time and I have a number of Kafkaesque memories of it. On landing in New York I had about $200, no place to live, and no job or prospects of any. I had one friend in the city, William A. Smith, a successful illustrator who had shared a studio with me in Paris for six months. Bill kindly let me camp in his apartment in the village until I could get my feet on the ground.

One of the high points of this low period for me was getting to know a number of abstract expressionist painters. At the time they were the hottest thing going in the galleries and museums. The Cedar Bar on University Place was their mecca and if you went there often enough, you could rub elbows with all the heroes of the day: Jackson Pollock, Franz Kline, William DeKooning, Mark Rothko, Robert Motherwell all gathered there. Through another friend, Herman Cherry, also an abstract painter, I became friendly with some of the 10th Street artists, and visited their studios and watched them work on their immense canvases. Since I had been out of touch with any of the new trends in art in America, all this frenetic activity made a profound impression on me. The paintings I brought back from Europe seemed tame in comparison. Whether it was due to my own insecure feelings at the time or just being around the force of all these bold paintings, it affected my work for about a year. Later, after a tough self-evaluation period, I threw away most of my work of that year, as it was a shallow rendition of what I wanted to accomplish, and it had no original content. It was a dead end for me. I was bored with this approach and even the language that is part of this type of painting began to wear thin. With any strong, new movement in art it is essential to believe in it wholeheartedly or your resulting efforts in that vein will be half-felt, and your work will suffer because of it.

Abstract Expression was an exciting but short-lived period of American painting. Though several well-known painters continue to work in this idiom, it doesn't seem to have the force and intensity it first suggested. One thing I learned, and it has stayed with me since, is their way of handling paint. Everyone should be exposed to a variety of techniques. For this reason I have demonstrated some of the newer methods of painting which are particularly useful in handling water based acrylic emulsions and other synthetic media. Some of these approaches became known as the "Action School of Painting." The prevailing idea was to reveal the ego through the physical *act of painting*—everything being subordinated to the motivating "activity" of painting. Strangely, this imageless, anti-formal painting is one of the few American schools that gained recognition in Europe.

On the following pages are several examples showing how some of this free-wheeling improvisatory painting can be achieved. Since subject matter has nothing to do with the problem, my demonstration only shows a few ways of going about it.

1 Using acrylic emulsion with a variety of large, cheap house painter's brushes, I let the colors drip as the paint is applied freely. These are very thin washes at this stage.

2 With the canvas on the floor, I use a large sponge to develop some color fields which will eventually change its luminosity as one area is painted over another.

3 While the acrylic paint is still wet, certain areas are wiped out with a sponge. Moving the canvas around on the floor, colors are wiped out and added.

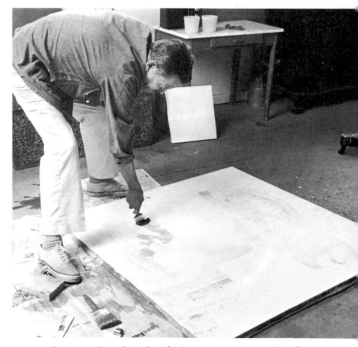

4 Using another brush, darker areas are painted over the dried washed-in areas. Much luminosity can be achieved by using a variety of colors one over the other.

CHAPTER NINE
SYNTHETIC MEDIA

IN THE 1950's, several abstract artists began using water base plastic paints before art suppliers started to package them in tubes. Artists like Jackson Pollock used some of the plastics and industrial enamels (the kind of paint used on automobiles) toward the end of his career. This had an influence on the next generation of painters who started the avalanche of synthetic materials. The Rhoplex acrylic emulsion medium came be known simply as acrylic emulsion which later developed such movements as Color Field Painting, Hard Edge Painting, Stain Painting and others. Even though these particular styles may not interest you, I urge you to experiment on your own to see if you like some of the effects that can be obtained by using acrylics. The main attraction of acrylic emulsion is its fast drying quality. Other techniques are adapted well to this medium such as fluorescent paints (better known as Day-Glo), pastel, crayon, collage (string, cardboard, wood, photos, marble dust, etc.) air brush, silkscreen, to name a few. One of the limitations of acrylic pigments is its insensitive blending quality and the drying time. Retarding agents are available to help overcome this problem, or you can use a water sprayer to keep your colors moist while working.

Another synthetic medium is Vinyl Emulsion (Polyvinyl Acetate) or better known as P.V.A. Karl Zerbe, the Boston painter, was a pioneer in exploring the possibilities of this medium by using fillers such as marble dust and powdered clay to build up the textural surfaces in his paintings. Since this medium contains a lot of glue, it has a brittle quality and should only be used on a heavy support such as masonite or well prepared canvas panels. P.V.A. on canvas will cause incurable wrinkling and buckling.

Another popular synthetic medium is Magna Paint (Bocour), which is thinned with turpentine. It can be used with oil paint, but does not mix with damar varnish. The advantages of this medium are its fast drying time—but not as fast as acrylics—and the transparent quality of shiny opaque surfaces when the paint is thinned with turpentine. It can also be used directly on raw canvas, unlike oil pigment. The best known painters who have used this medium extensively are Mark Rothko, Morris Louis, and Roy Lichtenstein.

Depending on your desired effect, Magna colors can produce glowing, irridescent surfaces or flat, opaque areas. Only Magna varnish should be used with Magna colors. The disadvantage of Magna is that it, too, has an elastic quality and does not blend like oils.

A final warning about brushes: any of the above synthetic media are tough on brushes. Be sure to use nylon brushes and keep them immersed in water when painting. Clean the brushes with soap and water immediately after use.

1 With lots of water added to the pigment, sometimes I squeeze the color on with a sponge. By tilting the canvas, the color will run in different directions and form bubbles.

2 This is how the bubbling effect looks when it is dry. A thin coat of paint can be applied over this area and the bubbled effect will still remain. Some painters I know use this technique for handling surf over sand in seascapes, but this is not the purpose here as no real images are intended.

3 After the original dripping has dried, some other large strokes are brushed over this area. Thick layers begin to build and various textures develop.

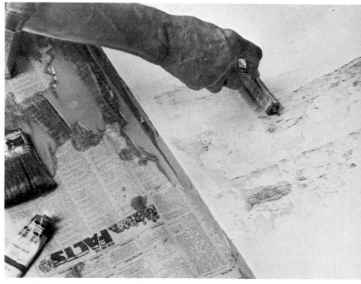

4 Here a brayer or roller is used to add other textures that have a grainy effect. I don't advise using this too often as it tends to stand out and look obvious. Bear in mind, experimentation is good, but don't exaggerate its importance by using it and letting it become a substitute for sound painting.

CHAPTER TEN
A GALLERY OF PAINTINGS

AT THE END of my classes, after we have reviewed the work in a critique and the students have left, there is always a feeling of melancholy that stays with me for some time. I have never been able to immediately shift gears and immerse myself in my own work. A haunting, brooding mood of self-analysis prevails for at least a day. In going over these pages I feel much the same way. I ask myself, "What have we learned? What have I said? and—more to the point—What should I have said?"

It is too bad painting cannot be taught like cooking, where we could all sit down at the end of the class and revel in a robust meal, devouring our accomplishments.

If someone were to ask me what is the most important thing to teach a student, my immediate reply would be "to see." And what is meant by that simple statement? It can mean so many things to so many different people, and it does not have much to do with the way I see an object compared to the way you see it. Perhaps responding is a better word. When Oskar Kokoshka opened his School of Vision in Salzburg in 1953, he said all he wanted to teach was "to see—only to see." I am sure that his former students would agree his teaching had much more to do with their response to nature than it did with the physical laws of vision.

At the outset of this book I said that only by varying degrees were a student's problems any different from mine. This brings up another problem I have not stressed enough: it is the capacity for risk—the willingness to change, to experiment, to reach and stretch out.

In discussing his preoccupation as a creative film producer, Woody Allen said one of the reasons he admires Ingmar Bergman is because he is not afraid to produce a movie that fails at the box office. He emphasizes, "It's very important that there's a certain amount of stuff one fails with. It has to do with putting a value on developing and trying to grow artistically. Some artists do not have that value. They find something they can do superbly, and they love doing it, and they keep on doing it, and the audiences grow to depend on it. I think that's a mistake."

Continued on page 102

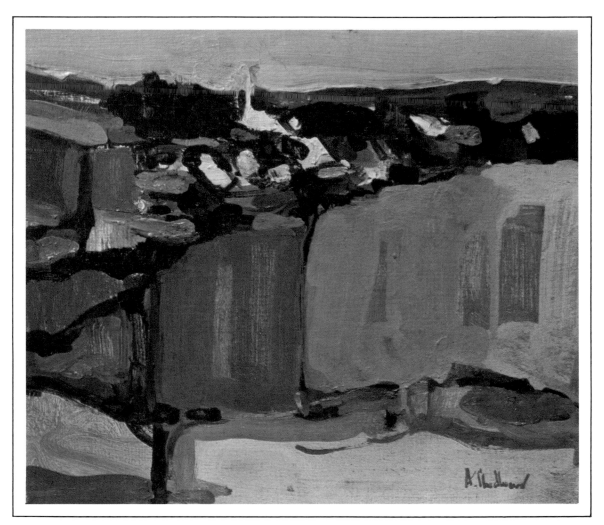

NEW ENGLAND VILLAGE
Oil on Canvas
Courtesy Barridoff Gallery, Portland, Maine.

While driving in Vermont, I stopped to do some small thumbnail sketches of this village as seen from the front seat of my car. Later in the studio I heightened the feeling of looking down by raising the horizon close to the top of the picture. My drawings were fragmentary and I didn't have much to go by. This was just as well as I wanted to keep the painting simple with large flat fields of color against a cluster of white buildings in the distance.

How many painters I've known who have fallen into this same trap! That is why I think it is so important to be able to take risks while you are still a student and explore on your own.

As a self-imposed form of criticism, I take all the work I have done for a year and line it up around my studio and take a long look at myself. In this way I try to avoid growing stale. Of course my remedies do not always work. Sometimes I find myself going back and painting some of the same ideas I had ten or twenty years ago in hopes that I will see the subject with a fresh eye. It is not a question of repainting old pictures; it has more to do with the refining and redistilling of former concepts. When Bonnard was accused of repeating older themes in his later years his favorite phrase was "Reculer pour mieux sauter"—of stepping back to leap forward. Braque said it another way, "Progress in art does not consist of extending one's limitations but in knowing them better."

CHEESE AND FLOWERS
Oil on Canvas
Collection Ms. Nancy Bowling, New York City, New York.

Sometimes, not very often, there are days when everything seems to fall into place and all is right with the world. This was one of them. The light was streaming over a dark corner of my studio after a rainfall creating an almost cathedral-like effect of light rays crossing the fresh flowers. The Brie was "a point" (just right to eat) and everything glistened on the table waiting to be painted. In this case I didn't make any preliminary sketches. I just wanted to paint what was in front of me. It was late afternoon and I had to do it rather quickly in order to capture the special light. Everything looked so fresh right after the rain. I also knew that I had to hurry before the Brie started to run off the table.

There are good and sometimes undesirable results when working fast. The good part is that a certain exuberance takes place as you become immersed in the act of painting. If a few accidents happen along the way, so much the better. The bad part is that tim should never have anything to do with the quality a finished picture. The fact that Rembrandt, Rube or in particular Van Dyke could knock off a finishe portrait within a matter of hours doesn't make it a more worthwhile or aesthetically more pleasing tha a Vermeer that took weeks to finish.

There is a watercolorist in Maine who advertis himself as "the fastest brush in the East." Qui frankly, this turns me off. Being "fast" or facile wi a brush has little, if anything, to do with good pain ing. As a matter of fact, when painting becomes to easy or effortless it might come back to haunt yo Sargent had this happen. Later in his life he began question the validity of some of his slick, quick wate colors. Unfortunately, I don't have this problem painting remains a struggle. Anyway, I had fun doir this one and the Brie and radishes were delicious.

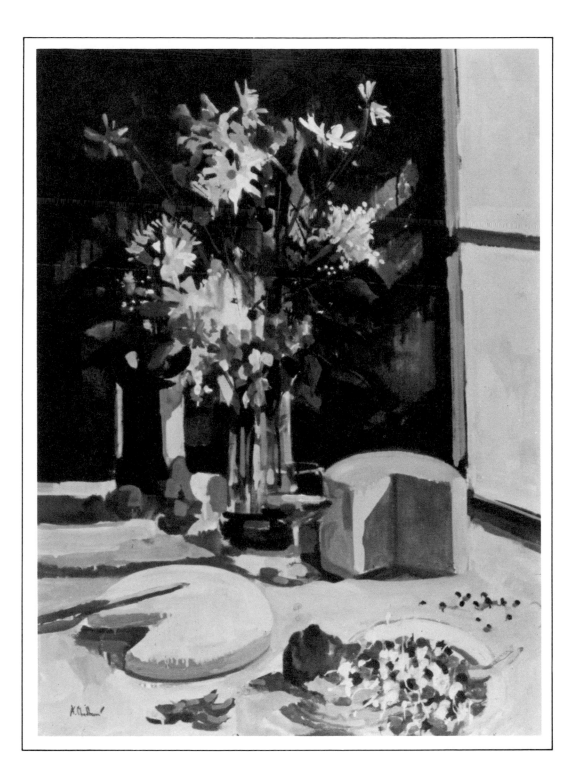

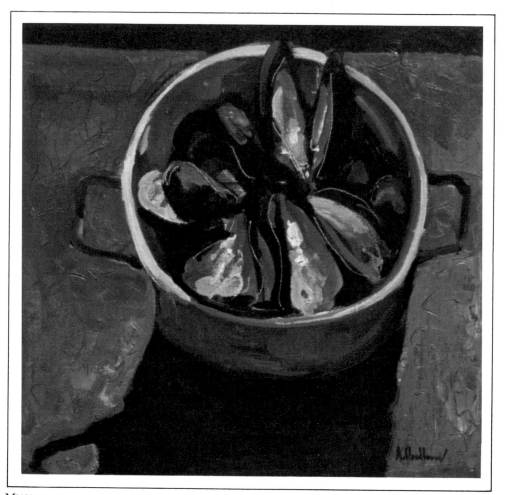

MUSSELS
14 x 14 inches — Oil on Canvas
Courtesy Barridoff Gallery, Portland, Maine.

This small painting came about after hours of false starts. I moved the mussels into various positions on the table until this composition eventually found itself on the canvas. I find it challenging to choose just one or two objects and see what can be done with them on a small canvas. After visiting a large show of Jean Simeon Chardin (1699-1779) in Boston, I was aware of the magic that can be expressed with such simple objects as a basket of strawberries or three mushrooms and a pitcher. Unlike many of the Dutch painters, Chardin was concerned not with the faithful imitation of objects, but with the poetry they evoke and with the properties of paint. The compelling interest in painting mundane, intimate objects can be explored further by looking at the simple bottles and jugs of Morandi or some of the small still lifes of Richard Diebenkorn, where a knife in a glass, a pair of scissors or an ashtray convey all the power and beauty of his larger canvases.

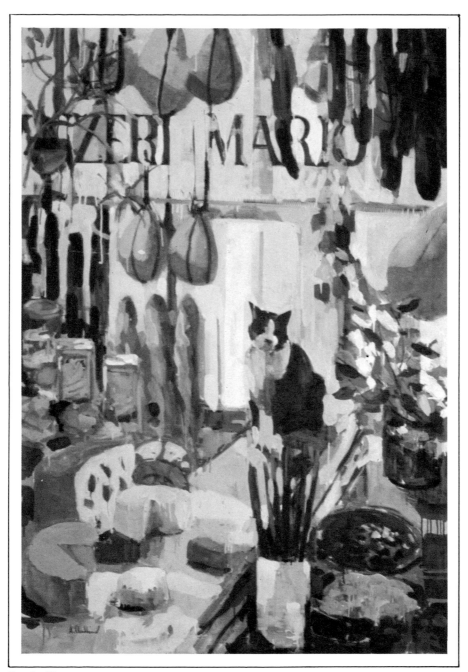

CAT IN DELI
60 x 40 inches — Oil on Canvas
Collection Mr. Icky Weber, Portland, Maine.

My insatiable interest in food has led me to do a great number of paintings and sketches of food stores. In Paris I was attracted to the famous "les Halles" or "bread basket of Paris," as Victor Hugo described it, and my more recent jaunts in Boston seemed to pull me to stores in the Italian North End. This painting was done from sketches in one of those delicious-smelling delicatessens in Boston. Usually I pave the way by sampling and buying a few slices of Genoa salami, a piece of cheese here, a few olives there. By that time there is enough of a rapport made with the owner to allow me to sit on gunny sacks of dried beans near the rear of the store where I can sketch freely without disturbing anyone. I love painting the large shapes of cheeses and sausages hanging in the window against the bright light of the street. In this case I added one of my cats in the picture similar to all those cats you see in European delis. Later I realized that I had not reversed the lettering on the window, but Mr. Weber, after buying the painting, did not want it changed so I left it.

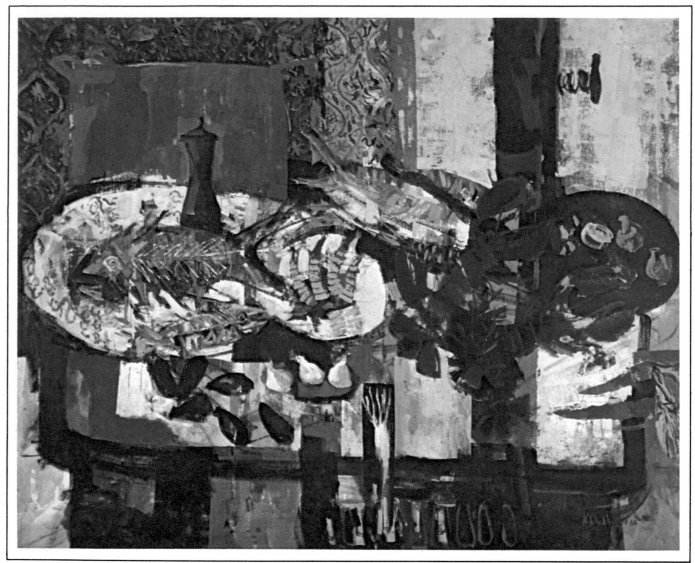

BOUILLABAISSE
40 x 50 inches — Oil on Canvas
Collection Mr. & Mrs. Richard Crabtree

At times while doing a painting demonstration of food, I have thought it would be better if I were cooking the stuff instead of painting it. No doubt many in the audience would concur. For those of you who enjoy the art of cooking and share with me the idea that painting and cooking is a way of living, I humbly add a recipe for a Meditteranean Fish Stew which incorporates some of the elements in the painting above.

Mediterranean Fish Stew

In the South of France there are generally two kinds of fish soups. The Bouillabaisse and the Soupe de Poisson, both of which will cause endless, lively discussions as to the merits of certain fish being used in the soup. The dogmatic attitude that only fish from the Mediterranean will make a true Provencal soup have long ago been disavowed by leading French chefs, particularly those such as Paul Bocuse, who has visited our shores and finds fish from American waters will produce extremely good soup.

In a way, this fish stew is a combination of both soups. The Bouillabaisse is prepared by first making an aromatic broth, then adding the whole fish to the broth which is cooked rapidly. The soup is served in a tureen and the fish separately on a platter. The Soupe de Poisson has the same taste, but is a strained soup, and generally is cooked longer. Sometimes a pasta is added to it to give it a light maison. In this version a fish stock or fumet is made first with the fish heads and trimmings along with the herbs and vegetables. This is strained and returned to the pot; then the fish and shellfish are added and cooked a few more minutes. Serve over hard toasted rounds of French bread.

MEDITERRANEAN FISH STEW

For the fish stock or fumet you will need the following:

1 cup minced onions	1 lb. ripe tomatoes or 1
1 cup minced leek	16 oz. can chopped,
½ cup olive oil	peeled tomatoes
4 cloves garlic, mashed	2 ½ qts. water
1 2-inch piece orange peel	1 bay leaf, ½ tsp. thyme,
salt & pepper	$1/8$ tsp. fennel
	2 big pinches saffron
	3 to 4 lbs. fish heads,
	bones, trimmings, (cheeks
	if available)

Cook onions and leeks slowly in olive oil for 5 minutes or until transparent. Stir in garlic and tomatoes, raise heat and cook five minutes more. Add the herbs, seasonings and water. Cook uncovered at a moderate boil for 30 to 40 minutes.

Strain the soup in a saucepan, pressing with a wooden spoon. Adjust the seasoning by adding another pinch of saffron. Reserve the broth and keep warm.

For the stew you will need:

3 qts. mussels or clams	1 lb. medium shrimp
1 ½ lbs. scallops, crabs if	6 small fillets of perch, sea
available	bass, porgy, or red snapper
2 lbs. haddock	1 bunch chopped parsley
1 cup light, white wine	

Clean and scrub mussels or clams and steam them open in the wine for about 5 minutes. Drain and add strained broth to fish stock. Bring the stew to a rapid boil and add the firm fleshed fish first, (perch, bass, porgy, snapper, etc.) Cook for 5 minutes then add the shellfish, (shrimp, scallops, crabs) cook for another five minutes and add mussels or clams at the last minute since they have already been cooked. Do not overcook. Serve from the pot or tureen and ladle into bowls over rounds of hard toasted French bread sprinkled with parsley. Serve with a basket of toasted French bread on the side and a bowl of that incredible sauce, Rouille. Or add one teaspoon of Rouille to bowls before serving.

SAUCE ROUILLE (Garlic Pepper Sauce)

This sauce is similar to the traditional aioli sauce except that it's pink.

2 red bell peppers
4 cloves garlic mashed
1 tsp. basil
½ cup olive oil
2 egg yolks
1 medium potato cooked in the soup
salt & ground pepper

Broil the peppers over the stove with a fork until charred. Cook and peel as much of the skin as possible. Chop peppers finely with mashed garlic in plenty of salt and pepper in a mortar or electric blender. Add egg yolks, basil, and potato and add oil drop by drop until it forms a smooth paste similar to mayonnaise, which it is. Season to taste. Just before serving, add 3 to 4 tablespoons of hot soup by driblets.

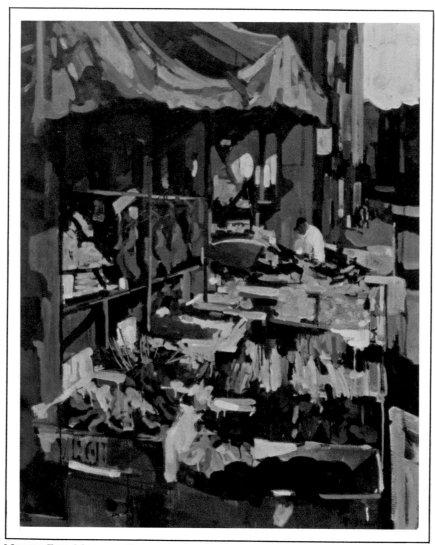

NORTH END MARKET, BOSTON
54 x 36 inches — Oil on Canvas
Private Collection, Portland, Maine.

One of the biggest problems I had with this painting was keeping the strong light and dark patterns of the awning in a reasonable relationship to the fruit and vegetables. I wanted to keep them both on a frontal plane. That's one reason the perspective of the sidewalk was forced almost to a vertical. Such problems are not always easily understood by the casual observer, but they are an integral part of the structure of a painting, and are just as important to an artist as any other part of the physical properties of a painting.

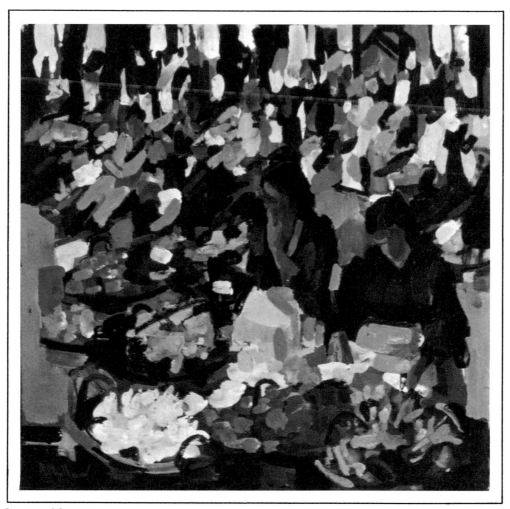

SPANISH MARKET
18 x 18 inches — Oil on Canvas
Collection Dr. & Mrs. J. Daniel Miller, Cape Elizabeth, Maine.

This painting was done from sketches during a recent visit to Spain. As with most subject matter that has been badly overdone by sidewalk artists, the first thing I try to do is clear my mind from any preconceived ideas before I start painting. One thing that caught my eye is that in Spanish outdoor markets, the vendors spread their wares on the pavement and sit on boxes or simple chairs. Thus, when standing, the shapes in my drawing looked flattened out. I tried to carry the busy pattern and color through a rhythmic feeling of design of the composition. These outdoor markets may not be as sanitary or hygenic as our supermarkets, but they are more fun to sketch.

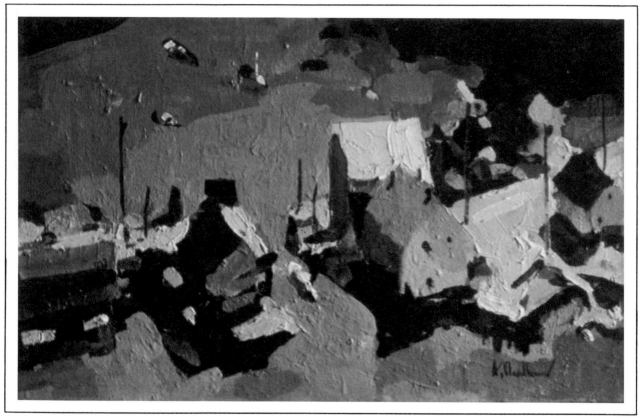

THE GUT, SOUTH BRISTOL, MAINE.
Oil on Canvas
Collection Dr. & Mrs. J. Daniel Miller, Cape Elizabeth, Maine.

This is a small town not far from where I live, typical of the small villages in this area. There is nothing particularly spectacular about South Bristol except that the town is divided by two inlets of water which are crossed by a drawbridge in the center, called The Gut. I've always been drawn to the pattern of small buildings built up on pilings and the clustered activity of small fishing boats anchored in the protected harbor. It's also the home of the famous Gammage Boatyard. My original sketches were done from two hillsides on either end of town. By forcing the perspective or cutting out the sky I felt I could get a more dramatic effect, as though it were an aerial view. In order to intensify the feeling of bright light I used straight ultramarine blue in some of the water contrasted with thick gobs of warm light pigment on the buildings and dock. I like painting small canvases with fairly large brushes, in this case bright bristles #10 and #7. This forces me not to get too involved with details. I confess to using a small line brush for the poles and windows added near the end.

110

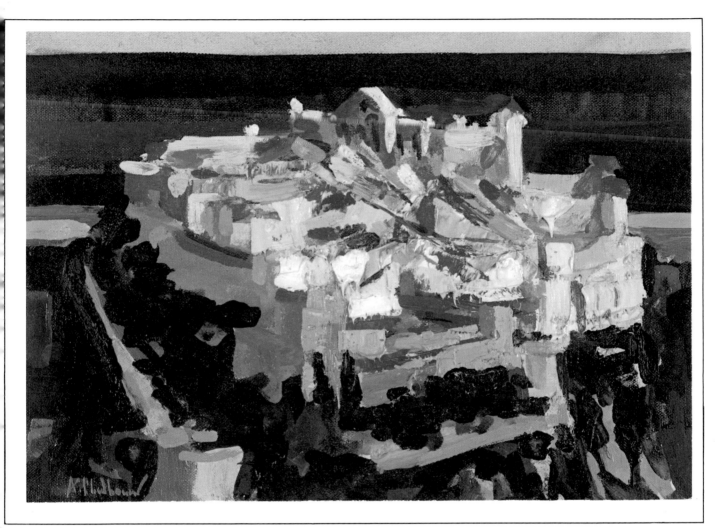

THE ROCK—MONACO
14 X 24 inches — Oil on Canvas
Private Collection, Monaco

This is a view of the palace in Monaco I used to see from my studio window. I never tired of watching the different light effects on the ochre and white buildings with red tiled roofs and the warm orange color of the palace set against the deep blues of the Mediterranean. It was like a crushed, shimmering jewel. I like painting villages from this distance as it becomes a massive shape, and there is no need to be specific about individual buildings. The "Rock," as it is called by the Monagasques, was captured by the Grimaldis in the tenth century and has been in Prince Rainier's family ever since.

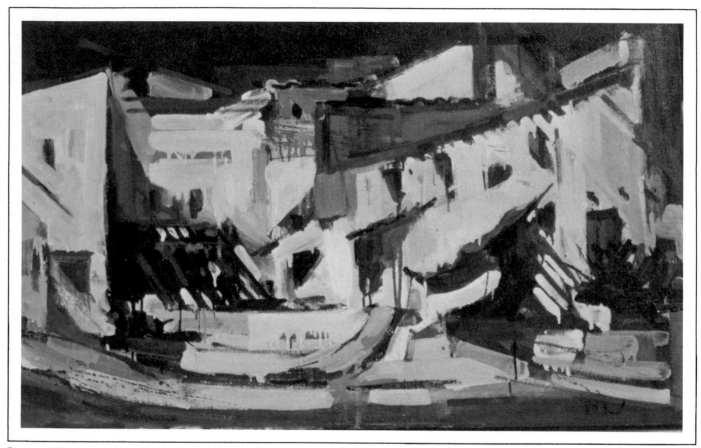

SPANISH VILLAGE—MAJORCA
24 x 46 inches — Oil on Canvas
Courtesy Barridoff Gallery, Portland, Maine

This is a rear view of the small village of S'Arraco, Majorca where we lived for two months. We passed this scene on our way home from the beach, and the changing abstract patterns of light and shade playing on the white buildings never failed to catch my attention. I did a couple of watercolors on the spot which turned out miserably and quickly ended up in the waste basket where they belonged. I kept my black and white sketches, however, and with a great deal of determination, came up with this version back in my studio in Maine weeks later.

Generally speaking, the villages in Majorca are somewhat somber in tone, mostly ochres and muddy siennas. Not the white villages I had remembered on the mainland of Spain when I visited in 1950. George Sand in her small, critical book "A Winter in Majorca" described the island as being "dour." This view of our town was one of the few places where I saw these white-washed structures although Minorca, the small island, abounds in a dazzling array of white, sundrenched villages. All activity in any Spanish town comes to a complete dead halt from about 1:30 P.M. to 5 P.M., which gave one the feeling of walking around the deserted, shuttered up street scenes in an Ingmar Bergman movie. I think the reason that my first attempts at this scene didn't succeed is because I'm always trying to take in too much when I paint on the spot. The fierce, steep mountains in the background, the road at the left leading through the town and other elements kept it from being a primarily flat design of just white facades with dramatic shafts of slanting shadows. Maybe this picture is a bit too empty and might have been helped by throwing in a group of scrawny goats, but even they were having their siesta wherever they could find a bit of shade.

112

WOMAN IN BED WITH CATS
50 x 30 inches — Oil on Canvas
Courtesy Barridoff Gallery, Portland, Maine

Having four cats around the house gives me ample opportunity to draw them as they loll about in fascinating positions. The ones shown here are particularly fond of our bed. I got up early one morning and made a sketch of them and then did the painting later. The large yellow orange cover was used to flatten out and simplify the other design elements of the painting. The nice part of working this way is that you do not have to worry about things like perspective. What is important is the overall flat design.

113

LAUTREC NAPPING
12 x 20 inches — Oil on Canvas
Collection Mrs. Grace Porta, South Casco, Maine.

Of all painters none would be as much fun to have known, I think, as Lautrec. In spite of his deformity and feeble constitution, he lived a life full of Rabelaisian splendor and his wit and charm seemed to have captivated everyone. This painting is from a photograph taken after he had eaten lunch and was napping by some shade trees. I added the glass of absinthe as I thought it appropriate to the scene. Lautrec was also a master chef and invented recipes which were illustrated with menus he designed to accompany his culinary festivities.

BONNARD
16 X 12 inches — Oil on Canvas
Collection Miss Janet Cowan, Alna, Maine

As I mentioned before, the work of Pierre Bonnard has had an overwhelming effect on me. For the sheer joy of color there is nothing more uplifting than walking into a room full of his pulsating canvases. Because I'm fond of doing paintings from old photographs, I chose this photo which captured the simplicity and dignity of the man. I added a poster in the background which was hanging in my studio, and took other liberties like exaggerating the length of the coat and simplifying the modelling of the head.

Bonnard had an unorthodox way of painting. He worked on several unstretched canvases at a time; each was attached to the wall with no other support. I wouldn't recommend this casual procedure to anyone. Frankly, I don't know how he managed it.

STREET SCENE—GENOA — Oil on Canvas
Courtesy Barridoff Gallery, Portland Maine.

Anyone who has walked the narrow streets of old Mediterranean towns will surely agree that they offer spectacular and colorful subject matter. This street happens to be in Genoa, but it could easily be Marseille, Naples, Barcelona or any other similar city. The laundry flying against the shafts of light against those steep buildings with shuttered windows has always been a very popular subject for painters. In this case I let the paint fly pretty freely since I felt the subject called for a rather broad, loose technique.

KITCHEN CHAIRS IN STUDIO
50 x 40 inches—Oil and collage.
Courtesy Barridoff Gallery, Portland, Maine.
Exhibited Bowdoin College Museum of Art, All Maine Biennial '79.

This painting was the result of a complicated arrangement of unrelated objects I found in my studio. I set them up for my students to paint. We were working on the use of collage with oil paint, and I began to demonstrate this technique on a large canvas. When the class was over, I didn't want to wipe out what I had started or destroy the canvas, so I began painting the same setup. Using Hyplar, I pasted the wallpaper patterns on first and then did some drawing with a large piece of carbon chalk. Another thin coat of Hyplar was painted over the wallpaper to protect it, making it possible to paint over the collage areas with oil paint. (Always paint any water soluble medium first, then add the oil pigment on top. Acrylic paint will not last over oil paint.) The nice part about working with acrylics is that it dries immediately and enables you to work over large areas without much trouble. As the painting progressed, I built up thicker areas of pigment where I felt they were needed, and in other areas, I let the original drawing show through. The idea of painting unrelated objects was to free our associations with subject matter to concentrate on the problems of design and color.

This is a photograph of the objects in the studio with a shaft of light crossing the floor.

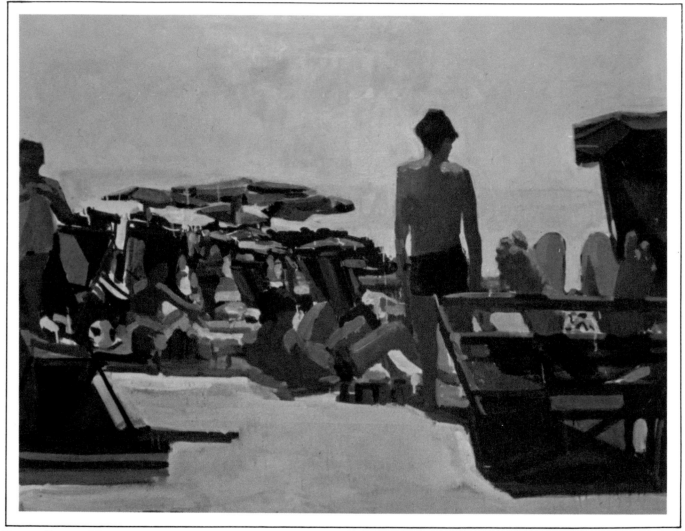

BEACH SCENE—MAJORCA
40 x 50 inches — Oil on Canvas
Courtesy Barridoff Gallery, Portland, Maine
Exhibited in the 155th Annual Exhibition of the National
Academy of Design 1980.

118

Anyone who lived in Europe thirty years ago would agree, I'm sure, that those little uncluttered beaches and coves on the Mediterranean that we used to discover and savor for ourselves are quickly if not completely vanishing. The island of Majorca in the Balearics off the coast of Spain is the supreme example of this transfiguration. Last year alone (1979), during the months of July and August, over two million Germans, one million English, half a million Americans, not to mention the thousands of Dutch, French, Scandinavians and others, teemed over this island which in square miles is about the same size as Long Island, New York. One can still find peace and solitude in some of the interior villages, but the beaches are swarming with humanity pretty much like the one depicted here.

Painting figures against the light can pose a lot of problems, but generally speaking you can come up with more unusual color combinations than you would under more normal circumstances. Some of the deep red violets on the figures and some of the pure deep blues in the shadows would jump out if it were not surrounded with all that white yellow light.

Since I am no great shakes as a master draftsman, I prefer the casual jumble of bodies so I can re-late more easily to shapes and patterns rather than struggle over anatomical accuracies. I did many rough sketches while I lolled in a rickety, vintage beach chair. Back in my studio in Maine, lots of changes took place during the actual painting even after I had settled on my basic composition. When you transfer a drawing to a painting, it will never look the same unless you adhere to complicated academic principles of the Renaissance by squaring off the picture. For me, something inherent in the physical handling of the paint changes my approach and I also believe that my thinking changes gears.

I have the conviction that many changes will and should take place up to the final moments of completion. If some large area does not seem to look right, don't be afraid to wipe it out, even if it means changing or destroying some of your original concepts—stand back and "let the painting talk back to you" as Diebenkorn has said. It's your response to these messages that is important.

Even though this painting took over two months of off and on work to complete, it felt good remembering the warm sand under my feet on these blistering beaches of Majorca while the snow was sliding off the skylight of my studio.

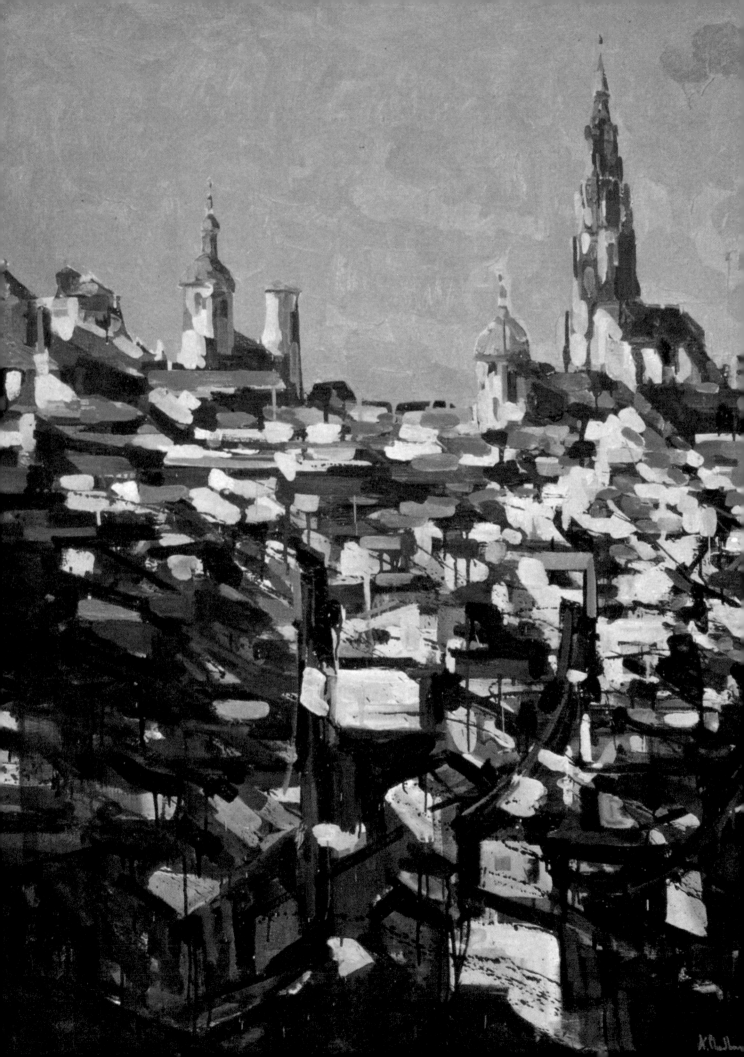

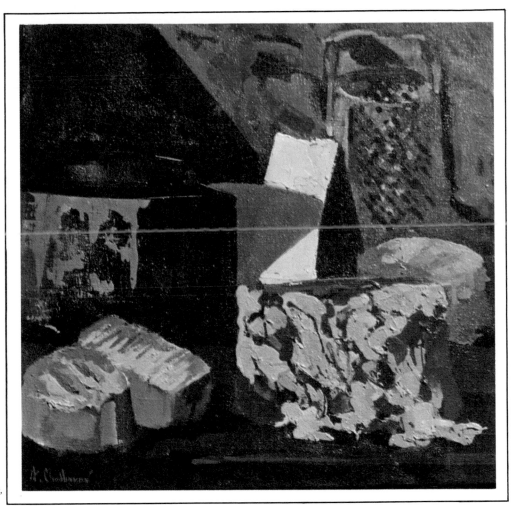

CHEESE
18 x 18 inches
Oil on Canvas
Collection of Mr. & Mrs. John Mills, Arlington, Virginia.

◄ VIEW OF TOLEDO
50 x 40 inches — Oil on Canvas
Courtesy Barridoff Gallery, Portland, Maine

El Greco's View of Toledo made a lasting impression on me when I was in art school. Upon visiting Toledo, one of the first things I did was to compare the original painting with my own impression of the scene. Naturally the city has changed a lot since the 16th century when El Greco painted it, but some of the same landmarks, like the cathedrals, are still very prominent. On a recent visit I did some sketches of the city as it appears today. There is no intention here to duplicate anything like El Greco's version of the scene, which was painted in low-keyed cool colors and a dramatic cloudy sky. In this painting I used warm, flat colors as I found it to be a very hot, dusty town. Cool colors were used in the darks of the jumble of buildings in the foreground, forming a circular pattern leading up to the cathedrals.

This small painting was done directly from Nature after a rather extravagant shopping trip to a good cheese merchant here in Portland. I spent more time in setting up this arrangment than I would normally because I was involved in the abstract quality of light and shade which helped transform the shapes so that the identity of the cheeses became a secondary consideration. In painting the picture I moved in fairly close to the table to block out or eliminate any surrounding distractions except for the cheese grater in the background. After lots of squinting and many sketches from different angles I finally got down to the business of painting what was in front of me. Because I don't think of myself as an ''eye'' painter like Manet and wouldn't dare compete with the Dutch Masters in detail I try to rely on those sensations and vibrations which hopefully reveal my fondness for this type of simple subject matter. The term ''eye painter'' refers to that often quoted statement attributed to Cézanne when he said of Manet ''All he's got is an eye, but what an eye.''

Once I was absorbed in the painting, textures played an important role in describing the shiny black outer crust of the large Vermont Cheddar, the ripe Camembert and the molding Gorgonzola. This may sound contradictory to what I've just said about identity, but it's pretty hard to ignore the textures of these objects while still striving for an overall abstract design.

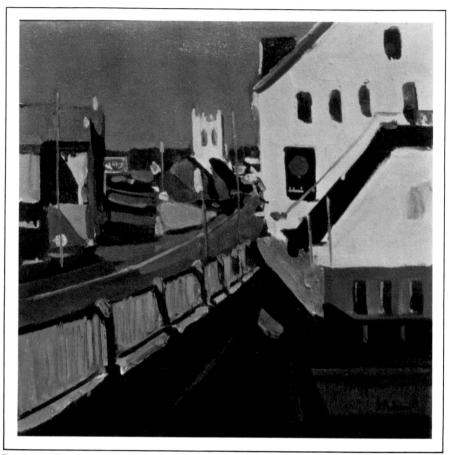

BRIDGE—DAMARISCOTTA, MAINE
18 x 18 inches — Oil on Canvas
Collection of Dr. & Mrs. Richard McFaul, Cape Elizabeth, Maine

I've passed over this bridge hundreds of times through the town of Damariscotta, Maine and was never that inspired to stop and do a sketch from this particular view. One very cold day out of desperation my class and I stopped to paint in a parking lot next to a gift shop that was owned by one of the students where we knew we could run inside and get warm by the stove if the weather really started to freeze up. I think we lasted about an hour before it got unbearable, but it gave me enough time to look at this scene from an entirely different point of view when I was helping someone sketch the essentials of the subject. It was like tuning in a fuzzy image on a television set. All of a sudden shapes, shadows and patterns began to clarify themselves and I became aware of the possibilities of doing a painting of the scene. I took a very rough thumbnail sketch home with me with the barest of information and a few jotted notes on color. I purposely worked on the painting at home and relied on future visits with the class to sharpen my memory of the place. The obvious dark diagonal shadow on the white building could never be that dark in reality and all the reflections on the moving river were purposely eliminated to strengthen the offbeat green angle of the bridge. For some reason I can never get myself to take these kinds of liberties when I paint literally as the painting gets filled up with a lot of unessential stuff that gets in the way of my original idea. After you've done a lot of outdoor painting I think you'll come to the same conclusion—that you can keep a better handle on the painting in the studio because you're constantly thinking about the picture, not the subject.

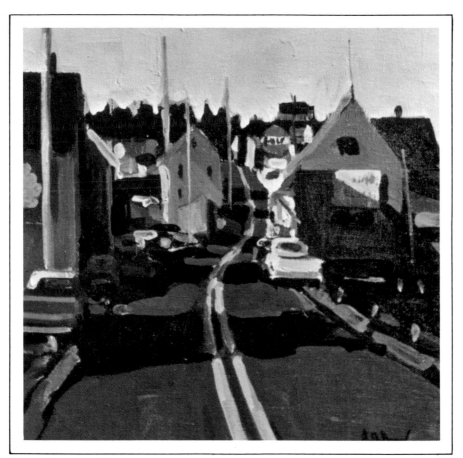

SOUTH BRISTOL, MAINE
14 x 14 inches — Oil on Canvas
Courtesy Barridoff Gallery, Portland, Maine.

Here's another similar view of South Bristol, Maine, of the black and white version on page (94). Although the composition seems identical, the color varies considerably, which for me changes the entire attitude or mood of the scene. In this case, deep, cool winter shadows were exaggerated to intensify the brittle quality of the signs, lights on the buildings and, of course, the double yellow line, running snake-like through the composition. I have no compunctions or remorse in exaggerating sizes or shapes of objects if I feel it will strengthen my design in order to exert more energy in my paintings. Those painted yellow lines would be almost three feet wide which in reality are no more than eight inches.

I've done another series of paintings looking at the village from the other side of the hill which brought on new impressions and new vistas to explore in order to broaden my vision and concept of the same subject. If you have found a particular place you like to paint or a tree or a field that excites you or moves you, be sure to exhaust all the possibilities of looking at it from all angles. Van Gogh completed over three hundred paintings within a few miles of St. Remy en Provence when he was confined to the asylum there and each painting evokes a different sensation. The same can be said of the endless versions of Mont Saint Victoire by Cézanne or in more contemporary terms the hundreds of paintings that bear the generic title of "Ocean Park" by Richard Diebenkorn. As the critic John Russell said, "Nowhere in them is there a dull or a thoughtless or a conventional mark".

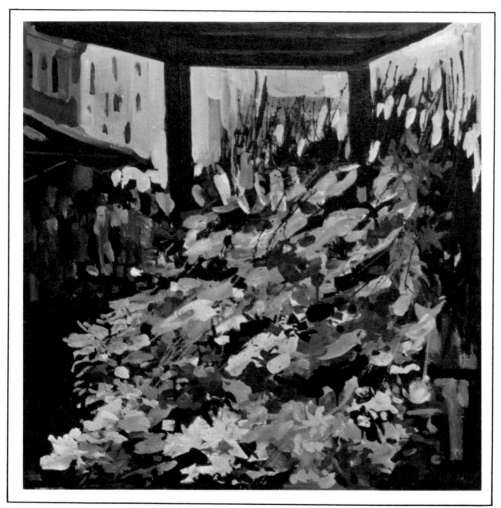

FLOWER MARKET—NICE
36 x 36 inches — Oil on Canvas
Collection Mr. & Mrs. Charles Sawyer, Washington, D.C.

The flower market in Nice is a big attraction, and every morning one whole street is filled with flower stalls. It is a dazzling array of color. A subject like this is always hard to organize until I can get back to the studio and rearrange my thoughts and my drawings. In this case I used a photograph as reference. I use photographs only for information and do not attempt to compete with the camera. Therefore, I feel quite free in taking liberties. The flowers were all in the shade which made a good strong dark shape against all the flickering lights behind the stalls. As the painting developed I felt more at home and began moving things around and only glanced at the photographs occasionally.

124

A SUMMING UP

IN READING OVER some of the manuscript, I realize that a lot of painters' names have been mentioned that may not be familiar to you. This is perfectly reasonable as I experience the same bewildered look from my students when we hold our critiques. Usually if I'm fortunate enough, I can point to a reproduction or a book may be handy to point out the various examples of the work in question. Nor do I want to appear like a "name dropper" merely to impress you with my knowledge of art. This could not be further from the truth or the purpose of this book. I hope, however, that it will kindle enough interest to look up the artist if he is unknown to you. I grew up with pictures and reproductions at a very early age, knowing painting was going to be my life's work. I've tried to keep an open mind about looking at pictures ever since.

When I was in art school, before World War II, in Southern California, the only paintings we were exposed to were in the Los Angeles County Museum. The walls were festooned with those sugary, sentimental eighteenth century paintings of the French and English Schools, which were bequeathed by one of the world's greatest junk collector, William Randolph Hearst. Visiting the Huntington Library near Pasadena to see Gainsborough's "Blue Boy" was considered a big deal. To be sure, there were a few good paintings which popped up from time to time, but nothing in comparison to the high quality of work which is seen there now. I remember hitch-hiking to the San Diego Museum when I learned they owned a Goya and I always envied any art student who lived near the Metropolitan Museum in New York City. Fortunately, all that has changed since that time and our museums are bursting with energy and paintings throughout the country. Believe me, today's student is much more knowledgeable about painting than I was until I got off a freighter in Antwerp and headed for Paris back in 1947.

There is one final thought that has disturbed me about art appreciation in recent years. Not long ago I was visiting a local art school having a rap session with some of the students. One of the young girls asked my opinion on a project which had to do with self portraits. Her painting was completely abstract and I thought her approach to the problem was quite unique. It had a lot of sensitive color,

but the design looked splintered and too busy. Her answer was that it was supposed to look splintered, busy and violent. Then I mentioned Goya in terms of using large masses of simple shapes to convey an abstract quality of violence not unlike Picasso's "Guernica". At the time there was a huge show of over 250 lithographs and etchings by Goya at the Boston Museum of Fine Arts, a little over two hours away by bus. I asked how many in the group had seen the show and only got about three hands. It seemed incredible to me that here was the grandaddy of violence and one of the world's greatest composers whose work was going back to be locked up forever in glass cases in the Prado in Madrid and this treat was shared by so few students. I am sure that if a show of Rauschenberg or Dine or Warhol were in Boston, the busses would have been jammed. I admire all three of these artists as they have, and continue to make, contributions to our present art scene. However, those students were missing something by being shockingly aloof to the art of the past. This in no way is to cast expurgations on the school or its instructors as I know most of them and they too would have been equally appalled by this narrow point of view. I remember one of my own younger students making the remark, "Oh, he's still painting seagulls," referring to the trite and banal type of art that we see in so many local galleries—what has been justly called "schlock art". I teased her by saying if Picasso were alive and had to be confined to the "boonies" of Maine and tried his hand at painting seagulls, I'd bet we'd see one hell of a seagull.

SUGGESTED READING

HERE IS A list of books that I have recommended from time to time to my students. Some of them are out of print and may be difficult to obtain unless you find them in your local library. I have added some personal comments to help clarify some of the text and titles. P.B. indicates paperback.

The Pelican History of Art, P.B. Painting and Sculpture in Europe 1880-1940. By George Hamilton, Penguin Books, 625 Madison Avenue, New York City, New York 10022

The Origins and Growth of Modern Art. Excellent balance between the general picture and describing the social forces at play. Includes good biographical detail of individual artists.

Picasso: Fifty Years of His Art, P.B. Alfred Barr. Museum of Modern Art, New York Graphic Society. A must for all Picasso enthusiasts. Well-illustrated and documented.

Vasari's Lives of The Artists, P.B. Edited by Betty Burroughs. Simon and Schuster, New York. A gossipy, opinionated, but fascinating account of the most eminent artists of the Renaissance. This classic sourcebook reads like a novel.

The Italian Painter of The Renaissance. Bernard Berenson. Phaidon Publishers Inc. Distributed by Garden City Books, New York. This elegant, aloof and eloquent man is the one responsible for putting such artists like Bellini, Botticelli and Piero Della Francesca in the important position they hold today. Some rough going, but well worth the pilgrimage.

Looking at Pictures, P.B. Kenneth Clark, Ballantine Books, New York.

Another Part of The Wood, P.B. Kenneth Clark, Ballantine Books, New York.

Both of these books bring scholarly insights and witty observations about the mysterious world of great collectors and connoisseurship. Erudite and candid self-portraits.

Letters to Theo, P.B. Van Gogh. Atheneum, New York.

One of the most tragic, heart-rending series of letters ever written. Much more powerful and better written than any of the more popular biographies.

The History of Impressionism, P.B. John Renald, New York, 1961.
The best history of this rebellious period.

Impressionism, Published by Realities. Chartwell Books, Inc. 110 Enterprise Avenue, Secaucus, New Jersey.

The best illustrated book on this period with good, large reproductions.

Recollections of a Picture Dealer. Ambrose Vollard, Boston, 1936.

Written by the man who first started buying and befriending the Impressionists.

The German Expressionists, Bernard S. Myers, Praeger, New York.

The most comprehensive history of this group which had so much influence on contemporary American painting.

The Art Spirit, P.B. Robert Henri, J.B. Lippincott, New York.

A very inspiring little book by one of the great American art teachers who influenced an entire generation of painters.

Modern Art, P.B. Herbert Read, Pelican Books, Penguin Books, 625 Madison Avenue, New York City, New York 10022.

The Meaning of Art, P.B. Herbert Read, Pelican Books, Penguin Books, 625 Madison Avenue, New York City, New York 10022.
Easy to read, well documented histories:

My Father Renoir, P.B. Jean Renoir, Little Brown, New York. Illustrated, charming biography with many amusing anecdotes.

Modern Art by Meyer Shapiro. George Braziller, New York.

Brilliant essays by one of America's great contemporary scholars.

Cézanne—The Late Work. Edited by William Rubin, Museum of Modern Art, New York,

Beautiful reproductions and excellent text. Better than most biographies.

An Artist's Notebook, P.B. Bernard Chaet. Holt, Rinehart & Winston, New York.

All You Want to Know About Techniques and Materials. This book updates Ralph Mayer's, *The Artist's Handbook*, as it contains complete information on synthetic media. Well-illustrated and thoroughly explained.

Drawing on the Right Side of the Brain, by Betty Edwards, J. P. Tarcher, Inc. Los Angeles. Distributed by St. Martin's Press, New York.
Don't let the title fool you. It is one of the best books on drawing particularly for students who have trouble seeing objects instead of shapes. Most of my students who have practiced the exercises have found it very helpful. The author claims that if you are left handed and your mother was also left handed there is no hope for you using her methods. One of my students falls into this category and for the simple, basic lessons on perceiving shape, proportion and perspective.

It didn't hinder her progress in any way.